IMAGES
*of America*

# SEQUIM-DUNGENESS VALLEY

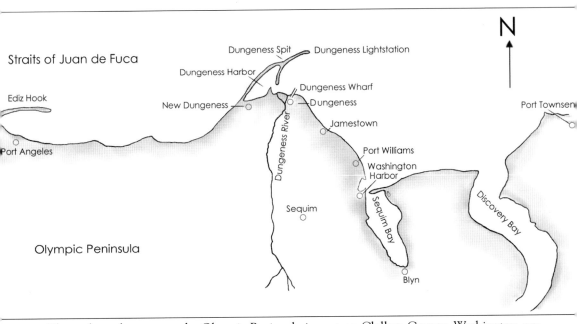

N

Straits of Juan de Fuca

Dungeness Spit
Dungeness Lightstation

Dungeness Harbor
Dungeness Wharf

Ediz Hook

New Dungeness
Dungeness

Port Townsend

Jamestown

Dungeness River

Port Williams

Port Angeles

Washington Harbor

Sequim Bay

Discovery Bay

Sequim

Olympic Peninsula

Blyn

The early settlements on the Olympic Peninsula in eastern Clallam County, Washington, are shown on this map. (Redrawn from a Medsker map by Katherine Vollenweider.)

**On the Cover:** Built by Joseph Keeler in 1908, the Sinclair Hotel in Sequim was a focal point for the town and a familiar backdrop for brass bands, parades, horse races, and boxing matches. Keeler, who started in Dawson City, Canada, during the Klondike Gold Rush "with three dimes when no one would take a coin less than a quarter," developed the town's utilities and started many commercial enterprises. (Courtesy of Sequim Museum and Arts.)

# IMAGES
## *of America*
# SEQUIM-DUNGENESS VALLEY

Katherine Vollenweider

ARCADIA
PUBLISHING

Published by Arcadia Publishing
Charleston, South Carolina

Printed in the United States of America

Library of Congress Control Number: 2015945082

For all general information, please contact Arcadia Publishing:
Telephone 843-853-2070
Fax 843-853-0044
E-mail sales@arcadiapublishing.com
For customer service and orders:
Toll-Free 1-888-313-2665

Visit us on the Internet at www.arcadiapublishing.com

*Dedicated to David Vollenweider.*

# CONTENTS

# ACKNOWLEDGMENTS

I would like to thank the following people, who generously contributed their knowledge, skills, talents, and time toward the completion of this project:

Judy Reandeau Stipe, Sequim Museum and Arts
Dr. Peter Becker
Chuck Fowler
Betty Oppenheimer, Jamestown S'Klallam Tribe
Bonnie Roos and Jan Jacobson, Jamestown S'Klallam Tribe Library
Carolyn Marr, Museum of History and Industry
Kathy Monds, Clallam County Historical Society
Kris Kinsey, University of Washington Special Collections
Michael Lange, Oakland Museum of California
Brian N. Cays, Olympic Peninsula Surveying and Drafting
John and Beverly Majors
Cherie Christensen
University of Washington Special Collections
Puget Sound Maritime Historical Society
Washington State Historical Society
National Archives and Records Administration, Seattle

Unless otherwise noted, all images appear courtesy of the Sequim Museum and Arts.

# INTRODUCTION

The term "Sequim–Dungeness Valley" puzzles me, as there is no northern counterpart to the Olympic Mountains that rise to the south, and no peaks en route west to Port Angeles. The Dungeness River empties a watershed of over 170,000 acres and drops at a 3.3 percent grade, but the upper river reaches are not the "valley" as used colloquially. The "Sequim–Dungeness Prairie" would perhaps be a more geographically accurate name, albeit offering a much different image than that of a pastoral valley with gentle, grazing cows. I hoped to find how the term originated in an obscure historical reference; instead, it may have come into the vernacular as recently as the 1960s, long after the town of Dungeness had reached its apex.

Our border to the north, the Straits of Juan de Fuca, was gouged by the Cordilleran ice sheets during the most recent glacial retreat. The passage from the ocean up Puget Sound is our defining corridor, enabling the coastal settlements that flourished and evolved into the towns of today. Those waters were essential to development for all the people—both the strong nation of the S'Klallam and those from other nations—who arrived from many countries and built a new homeland together, creating the history presented in these pages.

If I were to select one word about the Sequim Prairie and pseudo–Dungeness Valley's settlement, I would choose migration. Below us, the Juan de Fuca Plate continues to migrate under the adjacent North American Plate in what we hope will be a series of lightly staggered subductive bumps rather than one massive bang. Migration occurs among many species such as the salmon of the eastern Pacific Rim, whose routes are entwined in their DNA, driven by the scent of their natal streams. The ancestors of mastodons and mammoths, now entombed in local beach bluffs and ancient ponds, migrated across continents; one of their offspring became Sequim's famous Manis mastodon, which continues to be in the forefront of anthropological interest. People migrated across the Bering land bridge from places we have yet to determine, although we can now decrypt our origins through genetic analysis. Migrations of Euro-Americans followed, bringing precepts of English law and fueled by the dream of land ownership. A migration of technology occurred as the mills sought engineers, and new farming innovations arrived from the industrial centers to the east. The migrations stabilized as farms and towns were platted, until the recent migrations of retirees began.

For the purposes of this book, I chose an arbitrary endpoint of 1930. There is a plethora of new information available through periodicals and trade journals. Even after writing exhibit text for years as director at the Sequim Museum and Arts, I found historical information never before published. Archives and collections throughout the Puget Sound area had hidden treasures I gleaned through site visits. I browsed for hundreds of hours through microfiche and digitized newspapers—a forensic historian in search of clues to the past. Research time is like a sieve—so much front-end work for a short yield at the end—and it was easy to lose myself in the ledgers of time. It brought back memories of dusty, velvet-bound salmon hatchery records during my first historical sojourn into the California State Archives for the Monterey Bay Salmon and Trout Project while an intern at the University of California, Santa Cruz.

A scientific project always has a defined scope; before I began this book, I decided to focus on the continuum of events that allowed for the area's economic development. There were many elusive clues in the lineage of the mercantile business that underwrote New Dungeness–Old Town, and that lineage continued on to the new townsite, influencing the logging and dairy industries. For the readers' ease, I adopted the convention of "New Dungeness–Old Town" for the first settlement and "Dungeness" for the second and present town, as it reflects what the locals themselves called those places during their time. The research determined that there were far more people involved as investors and merchants than was formerly known. Sometimes those in the past called out from their digital footprints—men like Allen Weir, who grew up in Dungeness and became the first secretary of state for Washington.

Another metric I used in the writing of this book was to attempt to avoid duplication of photographs published elsewhere. However, given the fact that there are a finite number of images, except for the Sinclair Hotel, which seems to be the most frequently photographed building in Sequim's history, many images have seen print before due to the pivotal role they played in local history. I hope that the captions will bring a bit of new information to these photographs.

For those who are surprised at the number of steamships included, I can only reply that without those ships, this would have been a different place. There would have been no New Dungeness, and no Irish or English sailors would have jumped ship to settle and eventually be pardoned by Queen Victoria during her Jubilee. Without the ships, this would not have become one of Washington Territory's premier dairy production capitals, and there would have been no shingle industry, mercantile barons, or cannery empires. The whistles and creaking mooring lines of over 100 years of maritime trade have vanished from our purview with little trace except derelict pilings. I hope this book gives a glimpse into our maritime past.

To anyone who is considering taking on a project similar to this, be sure to account for all the contingencies of life that will most certainly occur once you commit. Rather than writing this book in the cozy confines of my study, it was written at Ediz Hook by lantern light in predawn hours, waiting for sport fishing boats to return with their catch; between shifts in work skiffs on Puget Sound, over the same grounds where the wakes of local steamships once dissipated; in airports and planes; on a research ship 1,500 miles off the coast of Mexico; and with a laptop more foe than friend, often plunging me into deep thoughts about the unappreciated value of parchment in today's world.

If your favorite part of local history is not included, it is your turn to write your story. To those of you who have a wonderful photograph that should have been in this book, please bring it to my friends at the Sequim Museum and Arts. There is always a way to make new information about our region part of the historical dialogue.

As for me, enough of my life has been spent ashore—the sea is calling and ships are ready to sail. May you have calm seas and fair winds on your journeys and may this book bring you a little joyful knowledge about this wonderful area.

# One

# THE S'KLALLAM TRIBE
## FOUNDERS OF JAMESTOWN

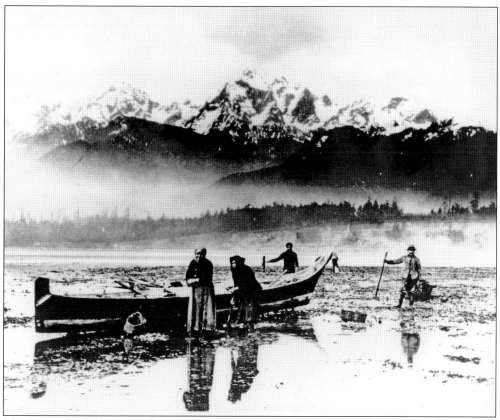

The Prince family harvests clams along the Straits of Juan de Fuca in this photograph. This was the land of the S'Klallam Tribe, who flourished for 10,000 years on these shores. The strong people had a governmental system and a diverse culture of art, stories, and songs that continues today. (Courtesy of the Jamestown S'Klallam Tribe and the Prince Family.)

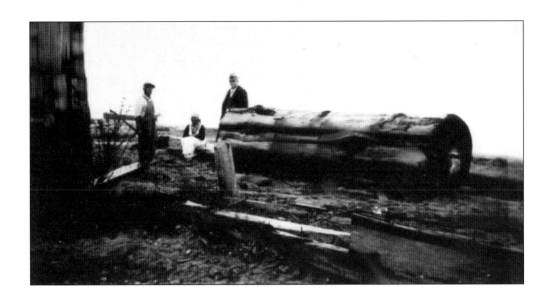

The photograph above shows a log at Jamestown being carved into a canoe. In 1945, Erna Gunther wrote in *Ethnobotany of Western Washington* that western red cedar was the "cornerstone of Northwest Coast Indian culture," used for canoes, homes, clothing, medicine, and more. The S'Klallam people utilized several types of canoes, including war canoes over 60 feet in length, smaller freight canoes holding up to five tons, and general transportation canoes for up to 15 people and ranging from 18 to 35 feet in length. The canoes were carved from 300-to-800-year-old trees in a lengthy process, assuring soundness. The photograph below shows one of the canoes used in the straits. (Above, courtesy of the Jamestown S'Klallam Tribe, Fitzgerald-Chubby family collection.)

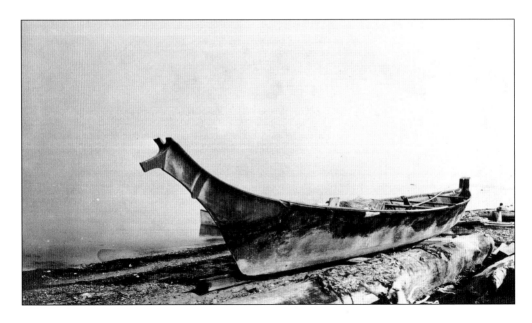

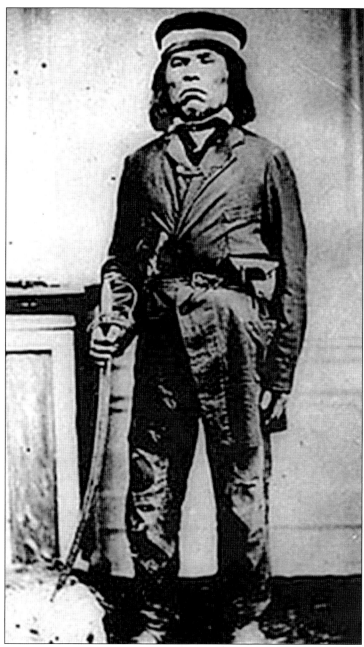

Chief Chits-a-mah-han, or Chetzemoka, signed the Treaty of Point No Point in 1855. The chief was also known as the Duke of York and his wife as Queen Victoria. Names of British royalty were often used in lieu of native names, as Europeans struggled with the complexities of the Salish linguistics. The S'Klallam lives changed with the Treaty of Point No Point. The tribe conceded their right to fish over 400,000 acres from Cape Flattery to Hood Canal, without which their survival was doubtful. The tribe was to receive a cash settlement, which languished for years. Arriving at the promised reservation land, it was found to be occupied, and the people returned home. Tribal members decided to purchase land east of the Dungeness River—ironically land in their own bioregion—and thus, Jamestown began.

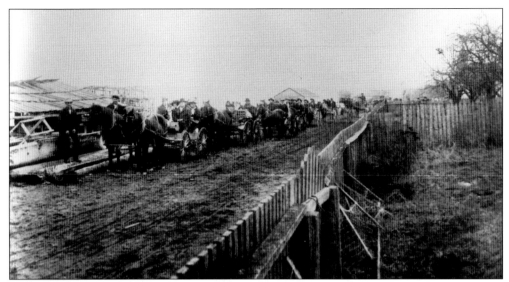

The photograph above shows a gathering at the Jamestown Church yard. The beach was the site of Shaker conventions and community events. During the harvest, many of the tribal members worked on local farms and for the Bugge Clam Company, harvesting clams. The document below shows the plats of Jamestown. Named for James Balch, the 210 acres were purchased for $500 in gold coins. The land was divided amongst the families according to the initial buy-in amount, and the lots were angled to provide beach access. (Both, courtesy of the Jamestown S'Klallam Tribe; above, courtesy of the Fitzgerald-Chubby family collection.)

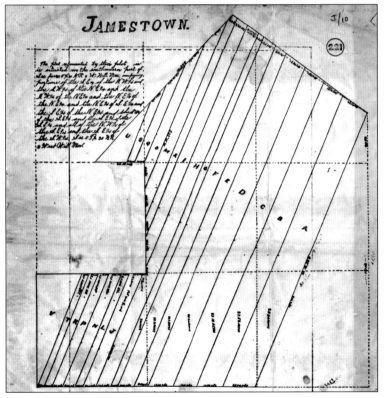

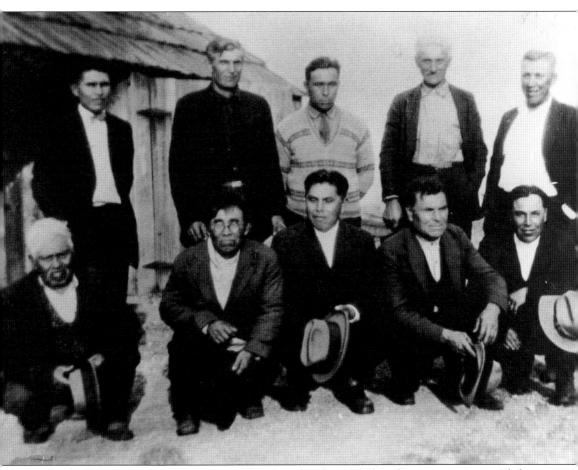

The Clallam Executive Committee of the three bands of Clallam (Jamestown, Lower Elwha, and Port Gamble) is pictured in 1926. During negotiations with the federal government to fulfill treaty promises, these men worked to determine the Roll of Clallam Indians, those people entitled to payments from the Clallam Relief Act. Pictured from left to right are (first row) Tim Pysht, Joe Anderson, Sam Ulmer, Charlie Hopie, and Benjamin George Jr.; (second row) Ernie Sampson, Joe Allen (chair), David Prince, William Hall, and Peter Jackson. In 1912, councils met to discuss how to address the tribe's numerous appeals regarding the unfulfilled treaty terms. Delegates were selected to go to Washington, DC, to ask for redress. Federal recognition of the S'Klallam as a sovereign nation did not come until February 10, 1981. (Courtesy of the Jamestown S'Klallam Tribe.)

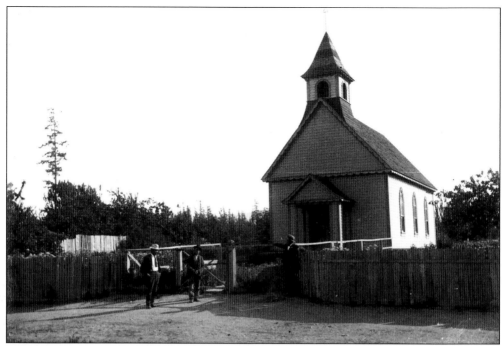

This Albert Henry Barnes photograph shows the Shaker Church in Jamestown around 1900–1906. The Shaker religion, Čənən Čənənáw'tw, came to Jamestown via the church in Port Gamble. John Slocum (Squ-sachtum) of the Squaxin tribe was the founder in 1882. Many government Indian agents at the time objected to the religion and attempted to impose a ban. Attorney James Wikersham intervened at a Shaker meeting in 1892 and asserted that freedom of religion assured noninterference. He then helped the members incorporate according to the state laws of Washington in 1910, thus bestowing legal status and enabling the practice to spread to other tribes in the state. The photograph below shows a group of Shaker followers in Jamestown. (Above, courtesy of the University of Washington Special Collections.)

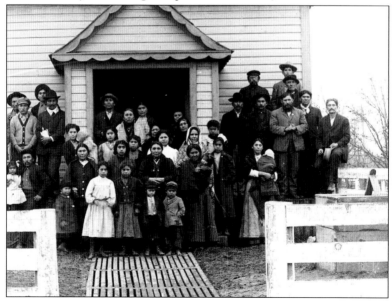

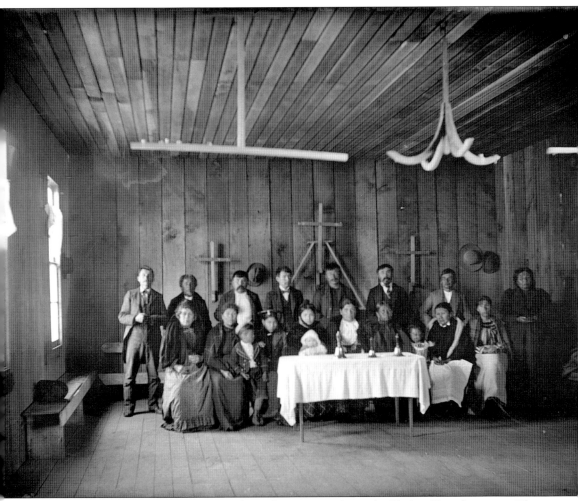

This 1903 group portrait by photographer Albert Barnes shows the Shaker Church interior. The Shaker movement reached Jamestown around 1890 to 1900. The *Leavenworth Echo* reported in August 1921 that "Six hundred members of the 'Shaker' conference of Indians at . . . Jamestown, near Sequim are now being fed by a miraculous run of [pink] salmon. Not for 20 year have the tides of July and August left salmon on the beach. Among the younger Indians the annual salmon runs on the Jamestown tideflat had become little more than legend. Last Saturday night . . . salmon by the thousand were swept up on the flats by the incoming tide and when it receded, hundreds were left entangled in seaweed. Indians harvested over the week-end the gift and rejoiced in the miraculous return of the fishes." (Courtesy of the University of Washington Special Collections.)

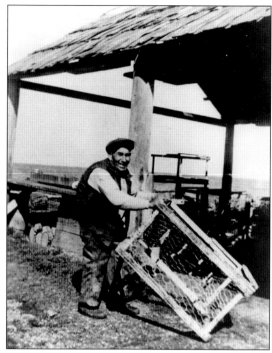

Jacob (Jake) Hall (left) crabbed between Jamestown and Dungeness in his boat *Diablo.* Hall ran a S'Klallam crew during harvest on farms or for the Hogue Pea Company, which leased croplands. Other tribal members worked in the cannery, at mills, or on logging crews. Hall was tribal council chair when the federal government compensated the tribe for the ceded lands of Point No Point. This enabled the first purchase of land in Blyn, where the tribal center is today. The photograph below shows one of Jamestown's early homes, the former residence of Harriet Adams, daughter of Jacob Hall. Her great-uncle Billy Hall was the Shaker minister. (Both, courtesy of the Jamestown S'Klallam Tribe.)

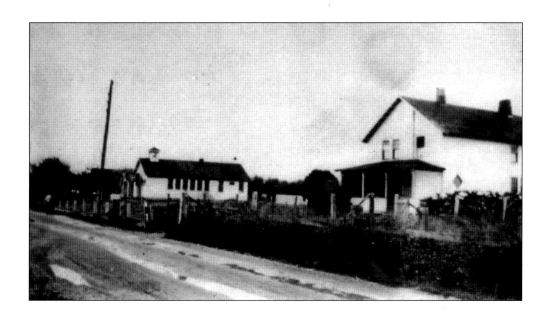

The photograph above shows Jamestown Day School. The first school was in the church built in 1878 by the Bureau of Indian Affairs. J.W. Blakeslee and Mr. Taylor were the two government-appointed schoolmasters. Another school was built in 1910. Johnson Williams, a S'Klallam member, had attended the Cushman Indian School and returned to teach. By 1921, students were attending Sequim schools. The photograph below shows the school and the church along Jamestown beach. (Above, courtesy of the Jamestown S'Klallam Tribe.)

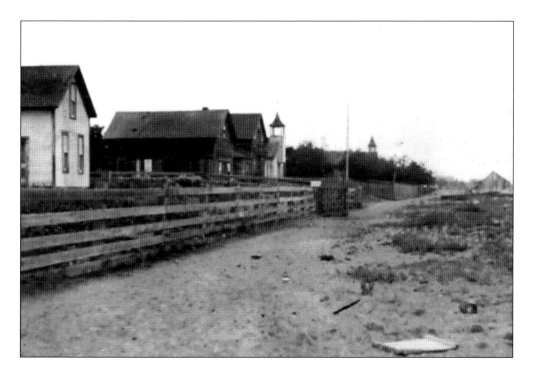

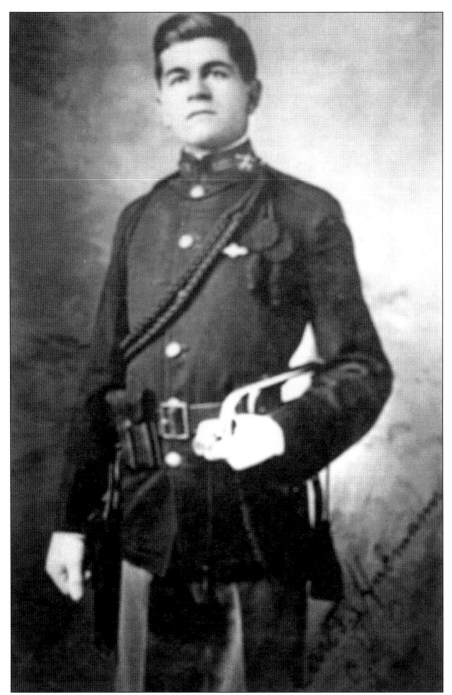

Tribal member Karl Joseph Hubman is pictured in 1919 wearing his military uniform. S'Klallam men served in World War I along with others from the community. The "strong people" were a resilient nation, surviving many threats including small pox, which had been introduced to the Pacific Northwest by the first European explorers. Today, the tribe flourishes and continues to create history with canoe journeys, art, and commercial endeavors. (Courtesy of the Jamestown S'Klallam Tribe.)

# Two

# Two Towns, One Name

## New Dungeness–Old Town
## and Dungeness

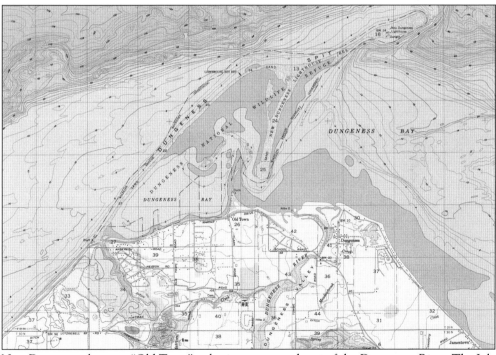

New Dungeness became "Old Town" as businesses moved east of the Dungeness River. The July 1, 1892, *Dungeness Beacon* reported that the postmaster general was assigning Dungeness as the new town's official postal delivery name. Both towns existed concurrently as businesses made the move from the late 1880s to early 1890s. A wharf existed at Old Town, and vessels with deeper draft used the services of S'Klallam canoes, scows, or small boats while anchoring east of the spit. This nautical chart detail shows the location of Old Town to the east of the spit and the site of Dungeness across the river. Visible are the two branches of the Dungeness River and the large area between, known as the Grove. For clarity, "New Dungeness–Old Town" and "Dungeness" will be used to differentiate between the sites.

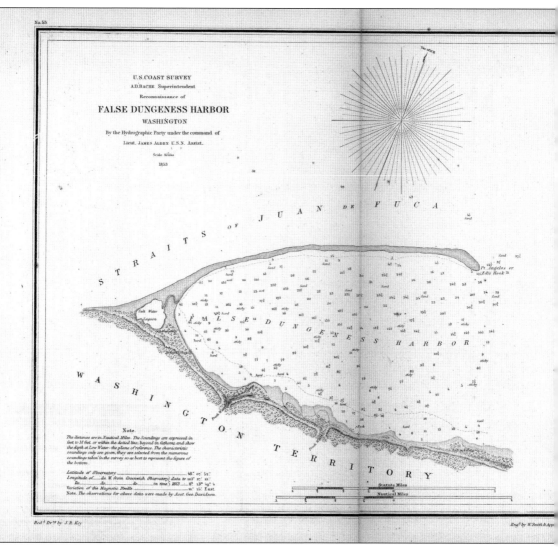

The Vancouver Expedition named New Dungeness for the headlands in Kent, England. The name persevered on charts, unlike those assigned by the Quimper Expedition. The Nootka Conventions of the 1790s quashed Spain's hold on the Pacific Northwest, though legend tells of a bottle containing the Spanish claim buried on the Dungeness bluffs, a geocache of international magnitude. Shown here is the US Coastal Survey of New Dungeness Harbor, showing small

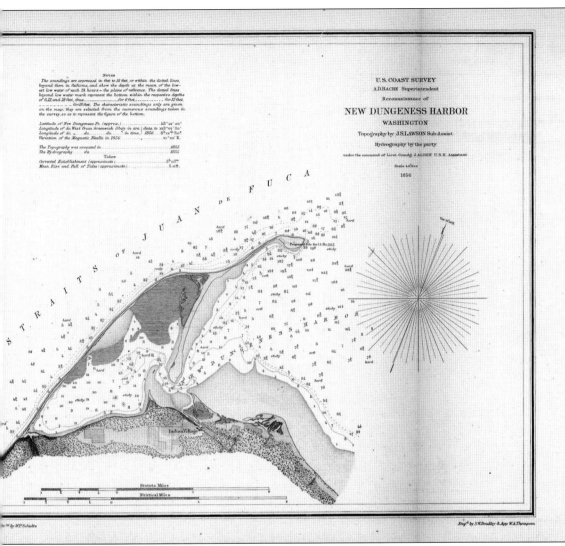

U. S. COAST SURVEY

A.D.BACHE Superintendent

Reconnaissance of

## NEW DUNGENESS HARBOR

WASHINGTON

Topography by J.S.LAWSON Sub-Assist.

Hydrography by the party

under the command of Lieut. Comdg J. ALDEN U. S. N. Assistant

Scale ⅕₀/₀₀₀

1856

J U A N   D E   F U C A

S T R A I T S   O F

Indian Village

Statute Miles

Nautical Miles

homesteads and the S'Klallam village south of Cline Spit. "Site of proposed lighthouse" is noted at the end of the spit. An extensive *estero* (shoal water) lay inside the harbor. Noted was the difficulty of removing anchors from the sticky bottom after riding out a gale. The portion of the survey titled "False Dungeness Harbor" is Ediz Hook in Port Angeles. (Courtesy of NOAA's Office of Coast Survey Historical Map & Chart Collection.)

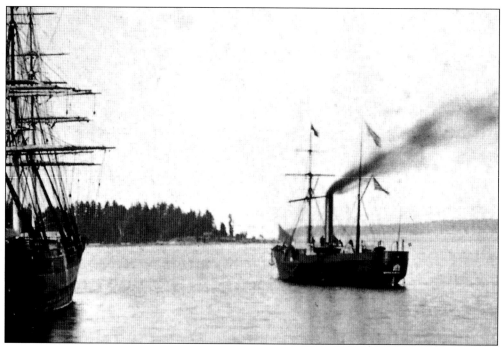

In 1855, Comdr. James Alden, Lt. George Davidson, and Lt. James Lawson surveyed the straits aboard Coast Survey ship *Active*, preparing the chart on the previous pages. Davidson established the astronomical stations at Port Townsend and Port Angeles. The *Active*, shown here, made 12 knots with her steam-powered side wheels. She was built in 1849 by Westervelt & Company Shipyards of New York and was 175.4 feet long. (Courtesy of National Oceanic and Atmospheric Administration, Department of Commerce.)

NORTHERN PACIFIC is the QUICKEST ROUTE TO ALL P

**NEW DUNGENESS.** The judicial seat of Clallam county, is pleasantly located on the Dungeness river, 20 miles west of Port Townsend, the banking point, and 76 northwest of Seattle. There are two hotels and two general stores. The shipments comprise live stock, grain and general farm produce. Population, 75. Mail, semi-weekly. Tel. P. S. C. F. Clapp, P. M.
Anderson J P, farmer.
Berry James, assistant lighthouse keeper.
Church Mrs Leila C, teacher.
Church Wm L jr, manager C F Clapp.
Clapp Cyrus F, general store, postmaster.
Clark Mrs Elsie, farmer.
Clark Thomas S, blacksmith.
**Clark Wm K,** County Auditor, Opr Puget Sound Tel Co.
Cline Mrs E, farmer.
Dungeness Hotel, F J Ward proprietor.
**Eureka Hotel,** O P Rollins Proprietor.
**Garfield Wm C,** Notary Public, Abstractor of Titles, Timber Land Cruiser, etc.
Guptill Miss Ella, teacher.
Jacobi Joseph, farmer.
King Clarles F, steamer captain.
Knapman John, farmer.
McAlmond E H, general store.
McGarvin John, wagonmaker.
Madison Charles, laborer.
Morgan O H, lighthouse keeper.
**Morgan & Hastings,** Proprietors Steamboat Line.
Morris John, Probate Judge.
**Port Townsend, Dungeness, Port Angeles and Neah Bay Route,** Morgan & Hastings Proprs.
Puget Sound Telegraph Co, Wm K Clark agent.
**Rollins Charles P,** Proprietor Eureka Hotel.
Shoemaker Miss, dressmaker.
Stolder John A, bookkeeper C F Clapp.
Ward F J, proprietor Dungeness Hotel.
Ward Wm, County Treasurer.

New Dungeness–Old Town became the county seat, poised to surpass Cherbourg (also known as Port Angeles). R.L. Polk & Company's 1887 *Puget Sound Directory* describes the town with "two hotels, and two general stores. The shipments comprise livestock, grain, and general farm produce. Population 75. Mail, semi-weekly. Tel.PS. [Puget Sound Telegraph Company], C.F. Clapp, Post Master."

Teacher's daughter Clara McDermott submitted an article to *The Atlantic* magazine in 1924, writing that "the little town . . . consisted of eight buildings. . . . on the right hand corner as you came up from the beach was the Hotel including a Saloon, adjoining was a store and . . . a harness makers shop, half a block father west was another general store and Saloon, then the Court House, the lower story of which was used for school during the Winter, in Summer school was held in different districts. Back of the Hotel on the south arm of the road was one small house . . . and across a slough a large two storey [sic] hall was erected by the Good Templar, for in spite of two saloons there was as strong G.T. Lodge, the lower story was used for dancing and socials week days and for church and Sunday School on Sundays." This blurry photograph of New Dungeness–Old Town is the only one known to be in existence.

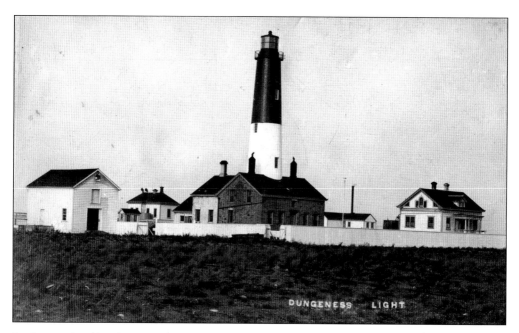

In *Coast Pilot of California, Oregon, and Washington* (1889), George Davidson wrote, "During the surveys of this part of the strait the Light-house at New Dungeness frequently exhibited the extraordinary effects of unusual refraction during the periods of calm and warm weather which prevail in the summer and part of the fall. At times the lighthouse tower would be raised up five times its usual height and then suddenly change to a low black line close to the ground." Opened in 1857, the light station had a third-order, fixed white Fresnel lens, manufactured by Henry LePaute. The keeper's dwelling appeared as a lower dark band to ships. Surveying brig *Fauntleroy* reported hearing the foghorn at anchor in Port Townsend. The tower was lowered 27.5 feet in 1927 due to structural concerns.

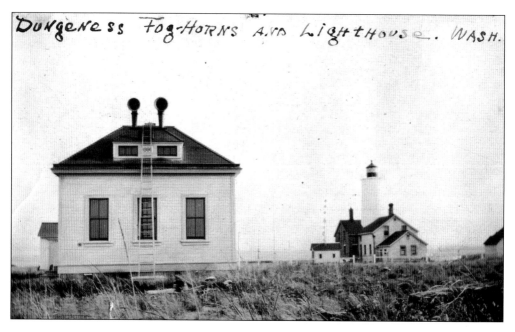

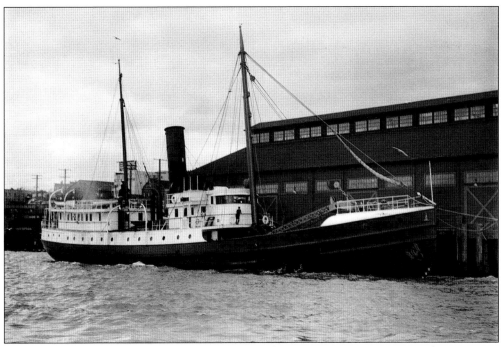

During 1892, a total of 3,247 vessels passed Cape Flattery: "1,563 steamers, 734 schooners, 494 barks, 333 ships, 119 sloops and 4 brigs," according to the *Dungeness Beacon*. This light tender, *Manzanita*, delivered supplies in 1912 for A.E. Withers to construct a tram, shown below to the right, providing keepers a way to haul supplies. Fuel for the lamps was delivered by ship to the remote light stations along the coasts of Washington and Oregon. This ship replaced the first *Manzanita*, which collided with the dredge *Columbia* while it was under the tow of tug *John McCraken* near Pilot Island off the Columbia River. The *Columbia* was being towed without running lights, had no proper lookouts, failed to respond to a steam signal, and thus, appeared to be conducting a stationary dredging operation. (Above, courtesy of Puget Sound Maritime Historical Society.)

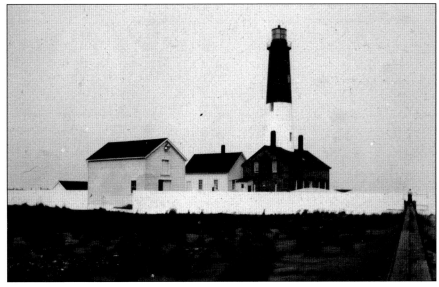

Cyrus Clapp began his career with a clerkship at Jordan Marsh & Company of Boston, the store that revolutionized the shopping experience by introducing innovations intrinsic to the department stores of today. Clapp's obituary in 1914 stated that he arrived in Port Townsend in 1870 with a cash capital of $5 in gold. He clerked at the Cosmopolitan Hotel in Port Townsend, which he later purchased along with San Francisco's Lace House. Clapp opened the Farmer's Store in 1879. One advertisement from the Port Townsend *Puget Sound Argus* of 1882 stated that cash and credit could be had for "hides, sheep skins, wool, eggs, oil, tallow, or any other farm produce you might have."

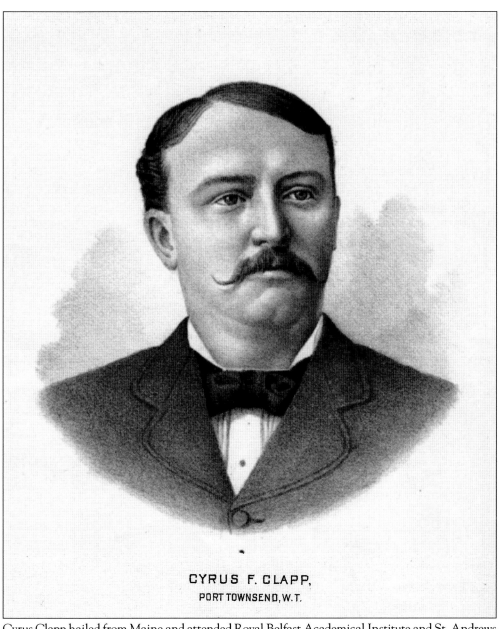

CYRUS F. CLAPP,
PORT TOWNSEND, W.T.

Cyrus Clapp hailed from Maine and attended Royal Belfast Academical Institute and St. Andrews College in Scotland. In 1893, Harvey Hines wrote that Clapp moved to New Dungeness in 1879 and "handled every variety of product in logs, lumber, and farm produce . . . with a sealing business in season and a freighting business about the lower Sound." He supplied seven logging camps, started pioneer trade, opened a post office, and became the owner of seven farms. He purchased Al Bartlett's store and expanded with a saloon, hotel, and restaurant. He built a wharf, warehouse, and the schooner *Granger*. In 1889, he moved to Port Townsend and organized banking house Clapp & Feuerbach, which became the Merchant's Bank of Port Townsend. Clapp was a state senator for two terms and a member of the House of Representatives in 1897. He later became a successful financier in Seattle. Clapp's legacy of mercantile commerce eventually evolved into the Dungeness Trading Company in 1896, an economic mainstay for Dungeness and Sequim.

In 1903, Alexander McAdie wrote that "the world today is literally gridironed with cables." The telegraph was the Internet of the late 19th century. Cables linked London to Brisbane, Australia, and on to Vancouver Island and Victoria. The 1887 R.K. Polk *Puget Sound Directory* listing for Cyrus F. Clapp's Farmer's Store states that New Dungeness–Old Town had Puget Sound Telegraph Company service. Above is a telegraph sent by Clapp, illustrating the major lines. The British government had capitalized the laying of the Red Line cables, and thus, termini were located at British territories throughout the world. Victoria was lined to New Dungeness–Old Town with 19.5 miles of underwater cable. The Commercial Cable Company linked San Francisco to Seattle, with other companies servicing the peninsula. (Courtesy of the University of Washington Special Collections.)

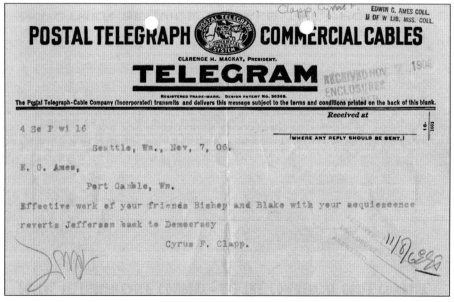

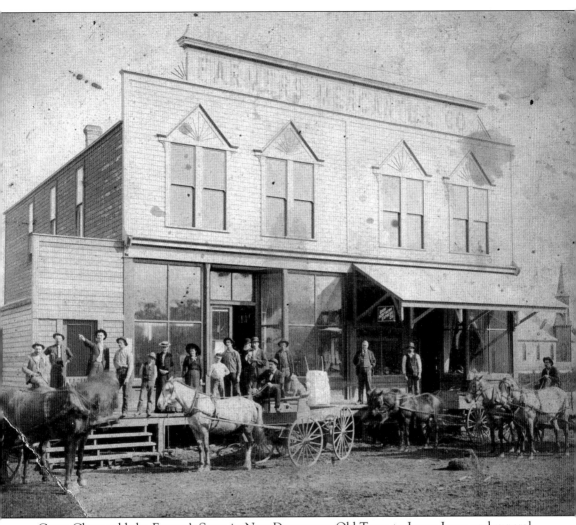

Cyrus Clapp sold the Farmer's Store in New Dungeness–Old Town to James Jones and general manager William Church in 1889. Jones divested to British Columbian Hamilton Lipsett, former purser on the steamship *Premier* and real estate broker in Port Townsend. Lipsett moved to Dungeness until 1904 and then became state bookkeeper. In *An Illustrated History of Washington* (1894), Harvey Hines wrote that Church and Lipsett incorporated with $30,000 of capital stock and formed the Farmer's Mercantile Company, with Church as president and manager. A new building (pictured) and a warehouse were built at Dungeness, while the first store continued operation at New Dungeness–Old Town with George Hunt as manager. The Methodist church steeple is on the right. The Great Northern Express sign refers to the Great Northern Railroad. Freight shipped on the railway arrived in Dungeness via steamship.

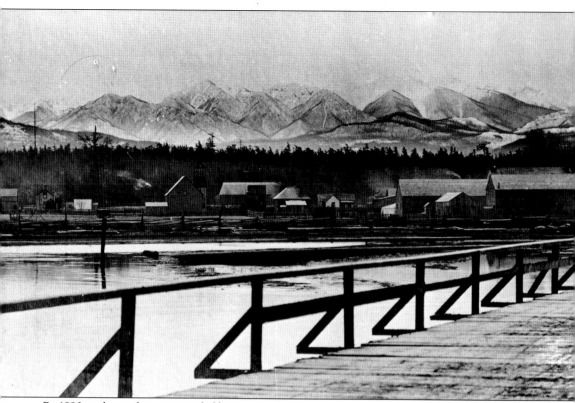

By 1890, realizing the town needed better port facilities in order to expand economically, Hamilton Lipsett, William Church, and others formed the Groveland Improvement Company. According to Lipsett, the Dungeness Wharf construction occurred from 1890 to 1891, built by Charles Gilmur of Port Angeles. Charles Seal, the cashier at Cyrus Clapp's Merchant's Bank in Port Townsend at

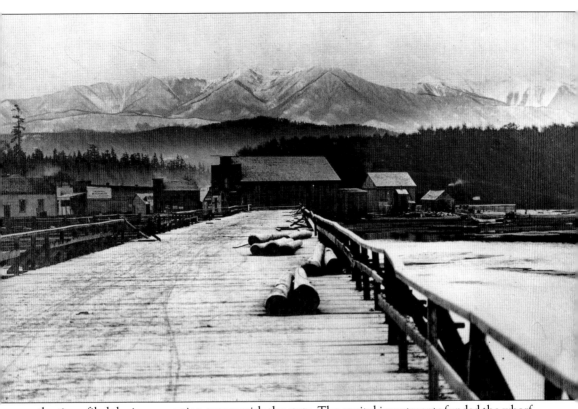

the time, filed the incorporation papers with the state. The capital investments funded the wharf construction and the purchase of James Merchant's Groveland Farm. This photograph shows the wharf and the town a few years later.

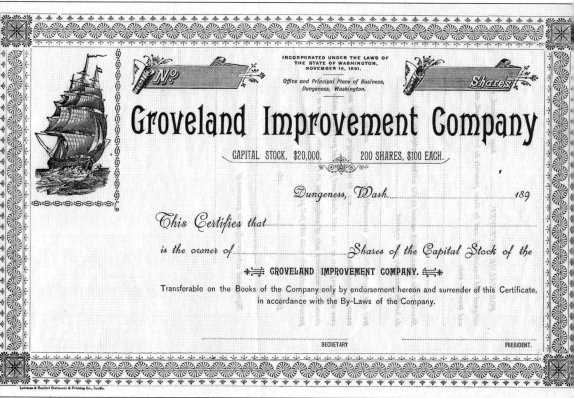

In *An Illustrated History of the State of Washington* (1894), Harvey Hines wrote that William Church was "president and was instrumental in organizing the [Groveland] Improvement Company with a stock offering of $20,000. This company started the town of New Dungeness [Dungeness] in 1882, where they made extensive and valuable improvements including a long wharf and a warehouse. They owned over 150 acres of land adjoining New Dungeness which is laid off in town lots, containing a store building and they also have a branch store at Washington Harbor. This firm, including the Farmer's Mercantile Company, transact all mercantile and shipping business in the eastern part of the county, and carry a stock valued between $15,000 and $20,000." Church was a postmaster, county surveyor, and county treasurer.

The *Dungeness Beacon* ran Hamilton Lipsett's Dungeness Land Exchange advertisement: "Over 1000 acres of land owned by the Port Discovery Mill for sale; bargains in 10 five acre tracts for gardening or berry raising; 300 acres of cleared land . . . Dungeness city lots for sale; Notary Public . . . agent for the State Insurance Company of Salem, Oregon; the Northwest Fire and Marine Company of Portland, Oregon, and the Canadian Pacific Railway."

# DUNGENESS BEACON.

VOL. 1.    DUNGENESS, WASHINGTON, FRIDAY, OCTOBER 21, 1892.    NO. 18.

Owned by R.C. Wilson, G.K. Estes, and Joe Ballinger, the *Dungeness Beacon* began publishing in June 1892, providing boilerplate world reports and copious information of national interest. A smaller section reported local news. By June 1893, the paper had moved to Port Angeles, and editorials focused heavily on whether gold, silver, or a bimetallic standard should back the nation's currency. The paper folded in 1893.

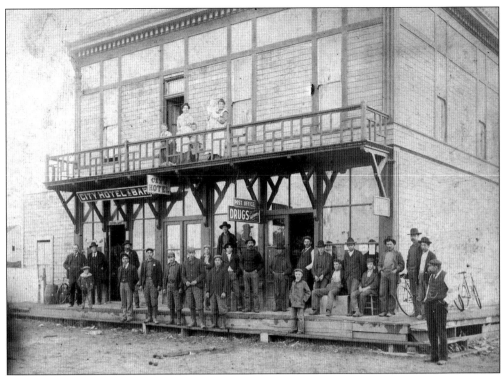

The City Hotel was built in 1892 by proprietor Elias Cays and was one of the early brick buildings in Dungeness. Board and lodging was by day or week; room rates were $2 and $2.50. The photograph below shows members of the Benevolent and Protective Order of Elks visiting Dungeness in 1903. The Fort Warden Band played from the balcony. The hotel burned in 1929 and was not rebuilt. William Monson, who had a store in the hotel, was a Garden City tailoring agent, offering "New York tailoring at home." Monson also sold a "complete Optimus Line of medical preparations including cough syrup, salves, ligament, headache remedy, laxative, and toothpaste . . . sold on the guarantee plan" according to the *Sequim Press*.

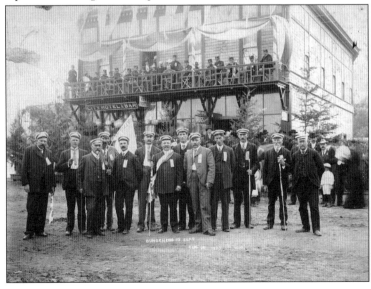

The 1892 *Dungeness Beacon* continually advertised the Sing Hi Chinese Laundry, located on an island in the delta formed by the two branches of the Dungeness River. A Chinese laundry was also listed across from the Methodist church on the 1897 Sanborn Perris map. Following the Chinese Exclusion Act of 1882, there were several accounts of human trafficking in local waters from ships originating in Victoria. Mr. Hang, shown at right, was one of many Chinese men who worked in Dungeness and Sequim. Charley Cays rented a farm for three years to a group of Chinese men to raise crops.

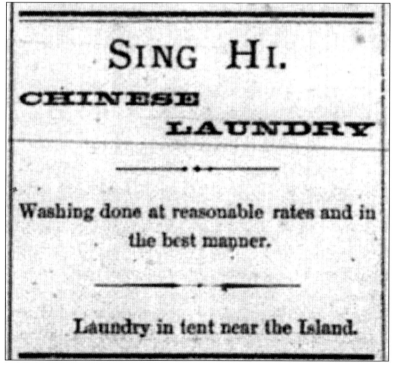

SING HI.

CHINESE

LAUNDRY

Washing done at reasonable rates and in the best manner.

Laundry in tent near the Island.

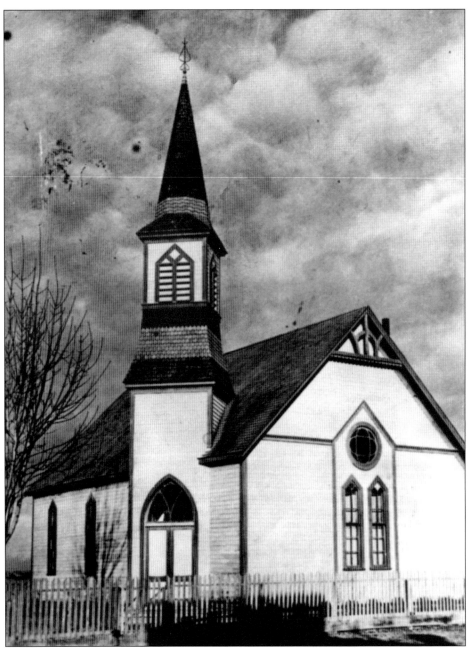

Reverend Patterson, a Methodist, visited from Whidbey Island via canoe in 1868, succeeded by Reverend Laubach in 1874 and Reverend Sharp in 1877. Reverend McNemee was appointed to the Dungeness Circuit in 1887. In 1889, the Grace Methodist Episcopal Church was built in New Dungeness with the help of Alonzo and Hall Davis. The church bell, shipped around Cape Horn, is on display at Trinity Methodist Church in Sequim. A new church building and parsonage was later constructed at Dungeness (pictured), and the original church from New Dungeness–Old Town moved to Sequim about 1905. The Dungeness Methodist Ladies Aid Society was one of the first organizations in the valley. Their Harvest Home dinner was described in the *Dungeness Beacon* of 1892 and is a community tradition that continues today as the Harvest Dinner.

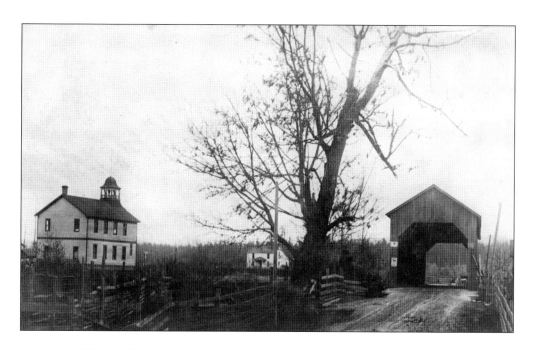

In August 1892, the *Dungeness Beacon* reported that the contract for the school was awarded to Hall and Duncan for $1,673. Construction was set to take 90 days, so it would be ready by November 1892. The building was 36 feet by 48 feet, two stories, with a belfry. The second wing was added later in 1921, and the school operated until 1955. The schoolhouse belfry contains the original bell, restored by Dave Bekevar in 2008 during repairs to the belfry that were supported by a community fundraiser held by the Sequim Museum and Arts, owner of the schoolhouse. A USGS datum point was placed on the southeast corner of the building in 1929.

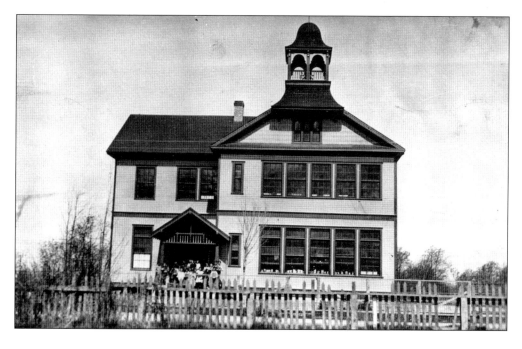

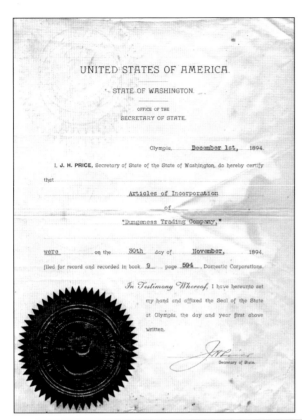

The Dungeness Trading Company was incorporated with a $15,000 initial offering on November 30, 1894, as the Farmer's Mercantile was facing foreclosure. Hamilton Lipsett was president and owned 50 shares; his name appears on the stock certificate below. Charles Seal left his cashier's position at Port Townsend's Merchant Bank at this time and moved permanently to Dungeness. The Farmer's Mercantile store was renamed Dungeness Trading Company. The Groveland Improvement Company continued as a holding company and brokerage. As years passed, Charles Seal reinvested his family's money to keep the company intact, although the Portland banking firm of Ladd & Tilden still held the mortgage on the trading company. William Church continued to live in Dungeness and became the Phoenix Insurance agent. Lipsett was elected to office in Olympia and then returned to the Port Ludlow Mill as bookkeeper.

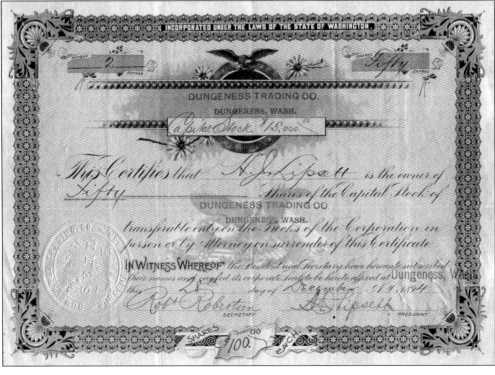

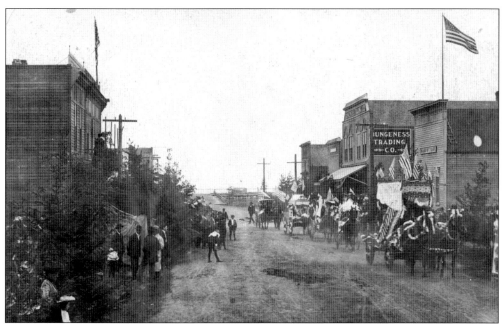

Among Dungeness's many businesses were Wilder & Cay's Brick Yard; Morse groceries and dry goods; Noble Turk's store; S. Beulieu, painter, kalsominer, and paper hanger; J.R. Thompson, physician and surgeon; Harlow & Harlow bricklayers and plasterers; and the Board of Trade Saloon (first building on the right), offering the "best assortment of wine, liquor, and cigars, etc. always on hand" with a private room and billiard table.

Joseph McKissick was born in 1870. His father died when he was three years old, and he went to live at the Hall Davis home in Dungeness. He had a photography business from 1902 until 1936. His studio tent was often seen at community events, and he had a studio across the street from the Dungeness Trading Company. Shown in this McKissick photograph is the Dungeness baseball team, posing before the tent and other McKissick prints.

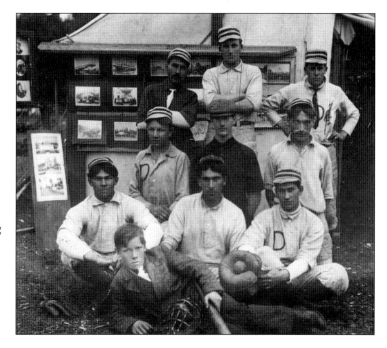

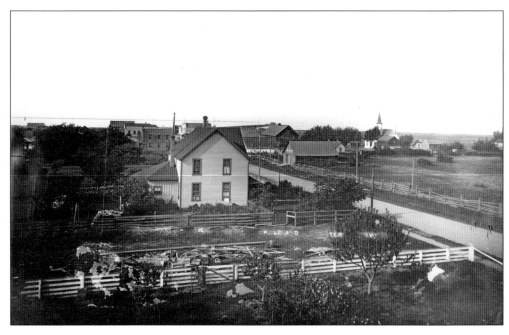

Both Charles Seal and Hamilton Lipsett brokered land, encouraging new farms and businesses. Shown are two photographs of Groveland Avenue. James Merchant's Groveland Farm had formed part of the new townsite purchased by the Groveland Investment Company. The name came from a grove of alders on the island or delta formed by the east and west branch of the Dungeness River. A footbridge led to the grove, a favored place for community picnics. The photograph above shows the Dungeness Light Station and the warehouse at the seaward end of the Dungeness Wharf, above the town's skyline. Dungeness Trading Company is in the distance; other large buildings are visible. The photograph below shows the Seal home, which stands today.

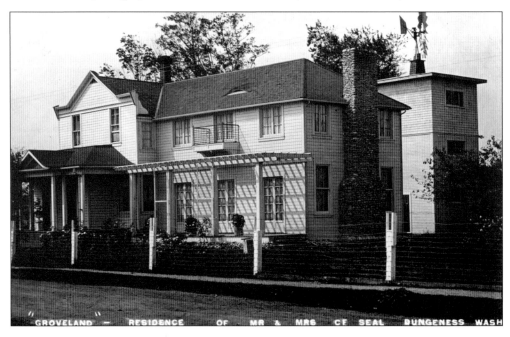

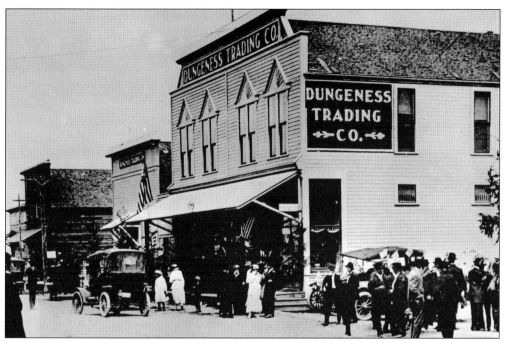

The Dungeness Trading Company offered trade for produce and extended lines of credit, keeping farmers in goods during the lean season between planting and harvest. The store and the wharf were the cornerstone for commerce but often fraught with difficulties, especially between shipments originating from the Coleman Dock in Seattle. Charles Seal wrote often to Seattle, inquiring as to missing or incomplete shipments, such as the set of coffin handles sent two short and rendering the remainder of the set useless. The company collected dockage fees (mooring charges) and wharfage fees on merchandise that left the wharf or warehouse. It maintained the wharf, which could be expensive. A steamship once took out 23 pilings during a mishap. The photograph below shows the street near the foot of the wharf, with a wagon transporting a new stove with a bread warmer top.

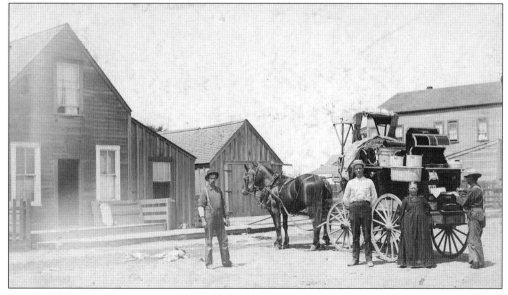

According to the 1898 *Northwest Dairyman and Farmer*, "A. Lingham, a nurseryman and seedman, moved to Dungeness where the fertile soil is well suited to thrifty nursery stock . . . sweet peas are grown in abundance . . . dahlias are grown in the leading decoratives, spring bulbs are grown to some extent, root crops, onions, cabbage, etc. result [in] large yields from a few acres. In both the nursery and seed line, he now supplies a large local demand."

In 1918, the *Sequim Press* reported that the Dungeness oil well was shutting down for a while. Dan Dalton had drilled a prospect oil well 3,500 feet and penetrated 10 feet of oil sand. The well was on Dungeness flat, east of the dock. The speculative well did not produce sufficient amounts of oil to be productive.

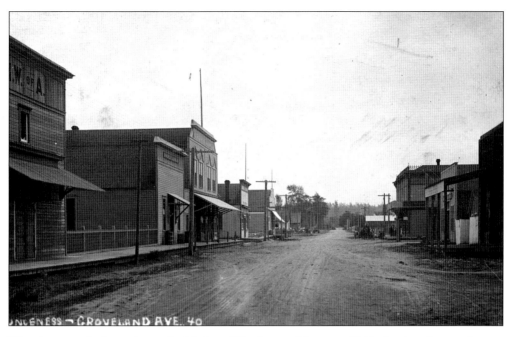

The photograph above shows the Modern Woodmen of America Hall, the site of many dances, dinners, cultural events, and holiday celebrations. To the left are the Dungeness Trading Company warehouse and store. On the right side of the street are the City Hotel (background left) and the Noble Turk store. The photograph below shows, from left to right, the City Hotel, Red Crown gasoline station, and the Dungeness Trading Company's Studebaker wagon and buggy store. The classic wood buildings were destroyed by several fires or disassembled and reused over the years.

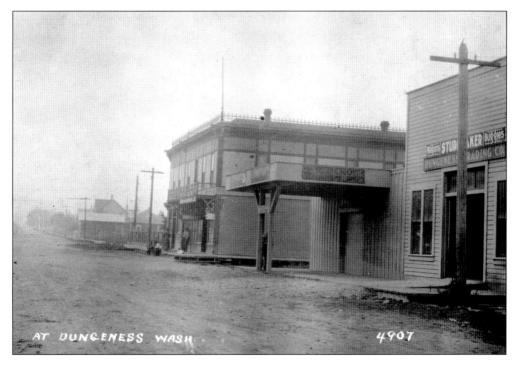

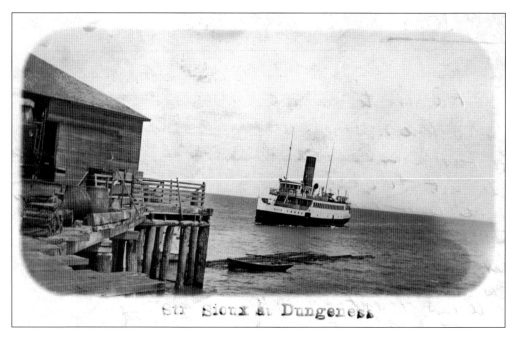

STR Sioux at Dungeness

The 148-foot steel *Sioux* approaches Dungeness in the photograph above. She was built by Joshua Green in 1910. In 1914, she ran aground on Dungeness Spit during a dense fog, remaining there six days until freed by two dredges. One of the dredges dug a channel on the seaward side, while another worked on the inshore side, making a channel to float the *Sioux* into deep water. The *Sioux* was the first commercial ship through the Lake Union Ship Canal in 1917. (Below, courtesy of the Puget Sound Maritime Historical Society.)

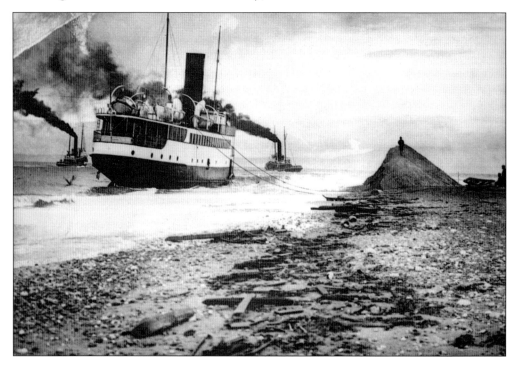

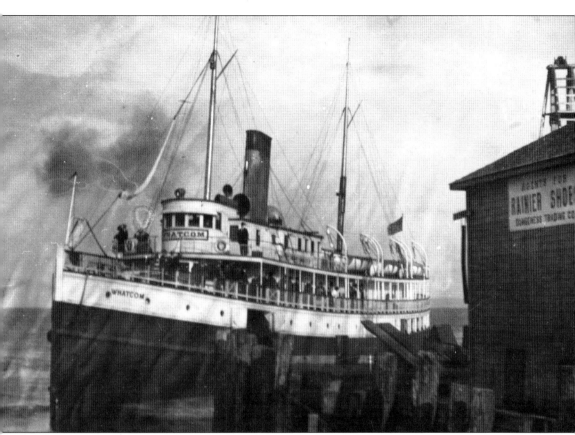

This photograph shows the wood-hulled steamship *Whatcom* with a Dungeness Trading Company sign reading "Agents for Rainier Shoes" on the warehouse. The 169-foot *Whatcom* was built in Everett in 1901 for $95,000 and launched as the *Majestic*. She was outfitted by Frederick and Nelson of Seattle, named as a promotion for their line of Majestic ranges. Under the Thompson Steamship Company flag, she ran the Tacoma to Whatcom route. She carried 400 people and had 30 staterooms, with an electric piano in the salon. Renamed the *Whatcom* in 1904 and then renamed the *City of Bremerton* in 1921, she was converted to a ferryboat in 1920 at the Todd Brother Shipyards at a cost of $100,000. John Rex and Fred Thompson had been engineers at the Puget Sound Cooperative Colony Mill and were the builders of steamship *Alice Gertrude*.

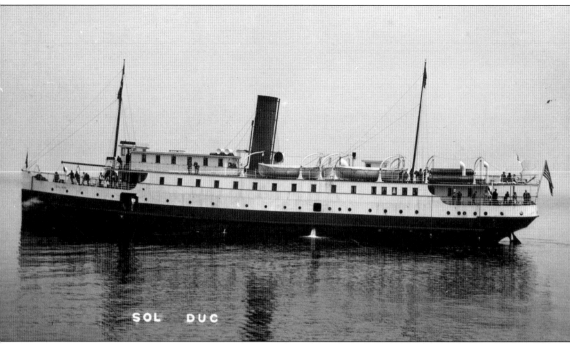

SOL DUC

The 189-foot steel-hulled *Sol Duc* was built by Moran Company for Joshua Green in 1912. Michael Earles opened Sol Duc Hot Springs Resort, and the Puget Sound Steamship Company named the ship to advertise and transport guests. *Sol Duc* left Coleman Dock daily for Victoria or Port Crescent. The following summer, she added the ports of Port Williams and Dungeness. Up to 453 day passengers enjoyed four decks, 39 staterooms, an observation room, a social hall, a dining salon, and a smoking room. *Sol Duc* had oil-burning water tube boilers and a triple-expansion steam engine, generating 1,400 horsepower and making 15.37 knots during sea trials. She had an 11-foot propeller and could hold 11 automobiles on the main deck; expelling air from the tires or unbolting windshields sometimes helped with the clearance on the side port. *Sol Duc* grounded twice on the Dungeness Spit with minimal damage, once in a 1916 snowstorm and later that year in fog. *Sol Duc* became a Navy barrack ship in 1942 and was scrapped in Everett in the late 1940s.

The Standard Oil Company ships *Petroleum I* and *Petroleum II* (pictured) delivered coal oil to the Old Town Wharf as late as 1908, according to Dungeness Trading Company journals. The Old Town Wharf and Dungeness Wharf were in concurrent use for years, as there are annotations of hay being shipped out from the Old Town Wharf by George Fitzgerald Sr. in 1908. *Petroleum II* had a cargo of coal oil (kerosene), a new substitute for the dogfish and whale oils formerly used in lamps. Fuel was shipped in barrels at the time. (Courtesy of Puget Sound Maritime Historical Society.)

Both the 214-foot *Iroquois* (above) and 97-foot *Garland* (below) stopped at Dungeness frequently. Built in Ohio in 1901 as a Great Lakes excursion boat, *Iroquois* was purchased by Puget Sound Navigation for the Victoria run and was one of the first two vessels on Puget Sound to be fitted with United Wireless Telegraph Company equipment in 1908. Mothballed during World War I, she was refit and converted to diesel by Black Ball Transport to freight on Puget Sound for 20 years. Sold as an Alaska fish-processing vessel, she was scuttled in the Gulf of Alaska in 1982 at age 80. The *Garland* was built in Port Townsend for the Hastings Steamboat Company, intended for towing and freighting. She was lengthened and fitted with passenger accommodations for the Victoria route. (Below, courtesy of Puget Sound Maritime Historical Society.)

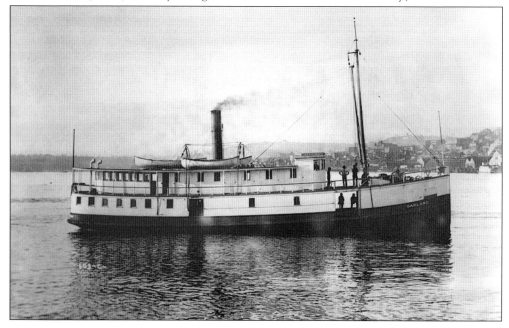

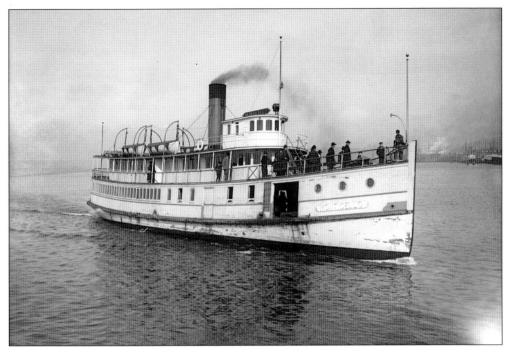

The 126-foot *Monticello* was licensed to carry 112 day passengers and joined the *Garland* in March 1893 on the Port Angeles to Seattle run. The July 1892 *Dungeness Beacon* reported *Monticello* was opposite Dungeness when the captain observed "a huge sea serpent wrestling about in the waters as . . . fighting with an unseen enemy. . . . it quieted down and lay at full length on the surface . . . about 50 feet in length . . . a terrible looking object . . . viciously sparkling eyes and a large head. Fins were seen, seemingly large to assist the snake through the water." Such serpent sightings are usually the rare but residential oarfish, shown below, whose total length can exceed 40 feet. (Above, courtesy of the Puget Sound Historical Society; below, courtesy of the University of Washington, Freshwater and Marine Image Bank.)

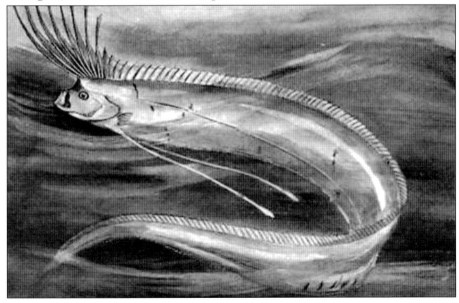

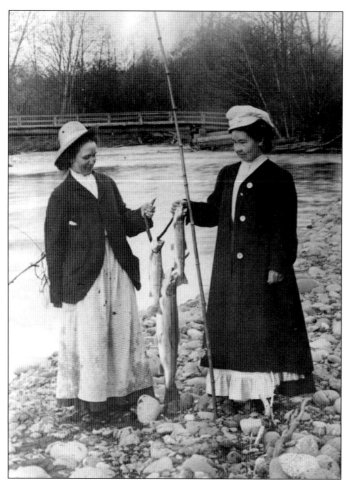

The photograph at left shows Lizzie Flemming (left) and friend sportfishing in the Dungeness River. Dungeness crab, clams, and salmon were lucrative commercial fisheries. In 1904, the deputy fish commissioners brought 15,000 steelhead trout from the Dungeness Hatchery to Lake Whatcom, as they matured to be seven to 10 pounds and were thought to be the best trout known to those waters. There was a fish trap in the Dungeness River's lower reaches, and the nets were stored at New Dungeness–Old Town in the Good Templar's Hall after the businesses had moved to Dungeness. Crabs were sold for 50¢ per dozen in 1893 and are pictured below being processed on the beach. (Left, courtesy of the Jamestown S'Klallam Tribe, Fitzgerald-Chubby family collection.)

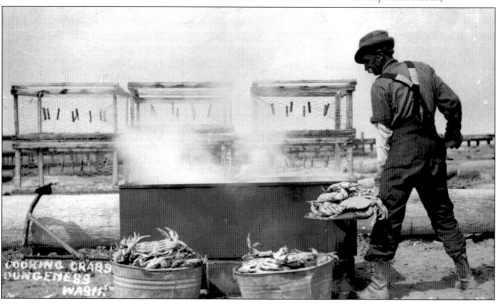

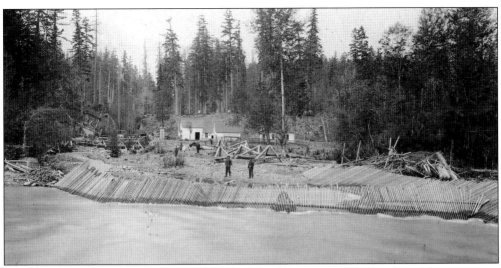

The Dungeness River Hatchery was built in 1901. By the early 1900s, habitat loss, fishing pressure, and strandings due to unscreened irrigation ditches affected salmon populations. The 1907 Fish Commission reports stated, "The irrigating ditches on the Sequim Prairie that take their water from the Dungeness River have in the past destroyed large numbers of young salmon. . . . [we] have taken steps to enforce the law with regard to the irrigating ditches." Logjams providing habitat were often removed to facilitate transport of logs to boom sites. In 1911, the *Dungeness Beacon* reported the 300-foot seine nets were "enormously remunerative;" the market price was 3¢ per salmon. Pictured above are the adult fish traps at the hatchery; below, Henry Knapman works inside the hatchery in 1904.

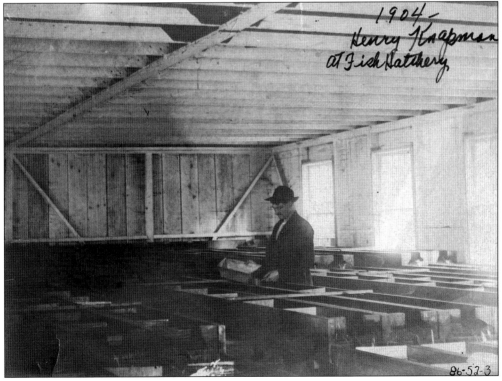

By the early 1900s, New Dungeness–Old Town was no longer the center of the community, and Dungeness was a thriving port, providing a viable way to export farm and dairy produce. When the railroad commercial clubs were beginning to investigate routes, the Groveland Improvement Company offered both land and cash, an incentive employed nationwide for perceived future gain. The railroad investors chose Sequim's incentive instead, ensuring its growth. By 1922, the era of the steamships had ended for Dungeness, and the wharf was sold to the Port District, maintained for the creamery. The pilings are still visible today, silhouettes that once framed the maritime center of eastern Clallam County.

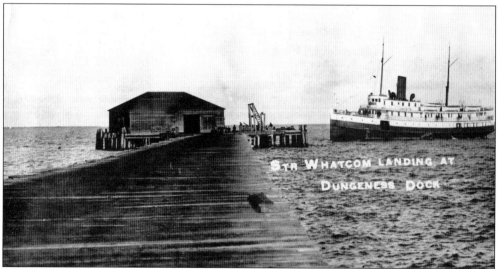

## *Three*

# FELLING THE GIANTS
## LOGGING IN THE
## DUNGENESS WATERSHED

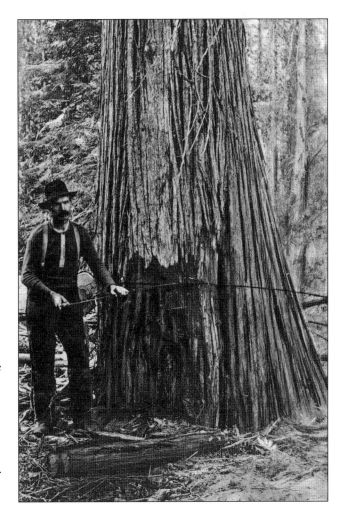

The sheer height and girth of ancient fir, spruce, cedar, and hemlock are difficult to imagine today, yet these giants once covered the area. Local timber supplied the California Gold Rush of 1849, and according to timber industry publications written at the time, met market demands for shingles worldwide. This photograph shows a cedar being felled in Dungeness.

By 1850, settlers were felling trees for spars and trading with ships in New Dungeness Harbor. The California Gold Rush created a demand for local timber. Hydraulic mining techniques required sluice boxes, and hundreds of miles of flumes were also built. In the Yuba River alone, miners moved three times the earth as was excavated for the Panama Canal. (Courtesy of the Oakland Museum of California.)

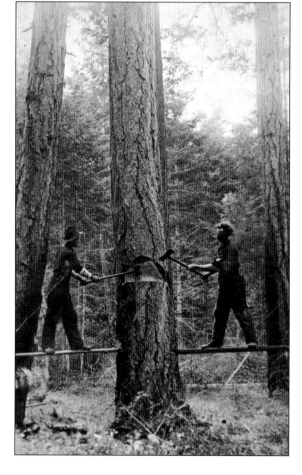

These loggers are standing on springboards, enabling a higher cut. The boards were about six to eight inches wide, with a metal end. In 1915 alone, the Dungeness Logging Company put 65 million feet of logs in the water, and Snow Creek did "about the same," according to the *Sequim Press*. Timber remained a major export into the 1900s, and the tools and methods remained very similar.

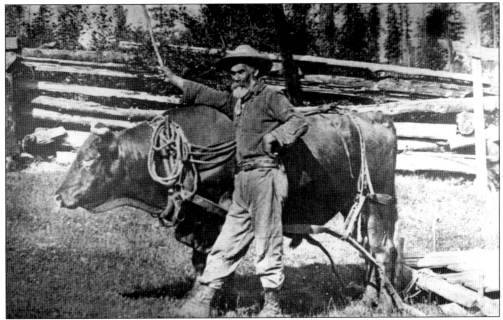

Oxen were an essential part of the early logging camps. Trained from a young age, they required special handling from bull punchers. They were yoked with a similarly sized partner for several years until they made their last appearance upon a plate in the cookhouse. This photograph shows local bull puncher Frank Romo.

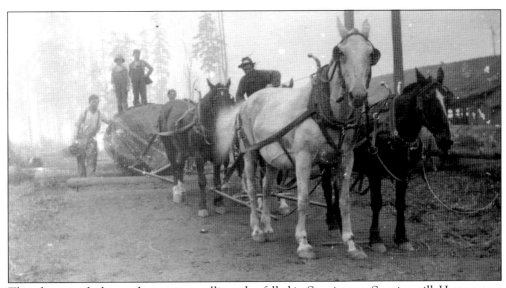

This photograph shows a horse team pulling a log felled in Sequim to a Sequim mill. Horse teams replaced oxen over the years in local logging camps as well as on farms. The change may have occurred as more local land was producing the hay or oats needed for feed or because workers were more likely to be experienced with horses.

For some local residents, such as Frank Romo, shown here with his grandson, oxen remained the draft animal of choice. Romo raised, trained, and drove oxen with a go-devil (logging sled). Millions of oxen are still used worldwide and still seen in rural America at pulling meets and fairs.

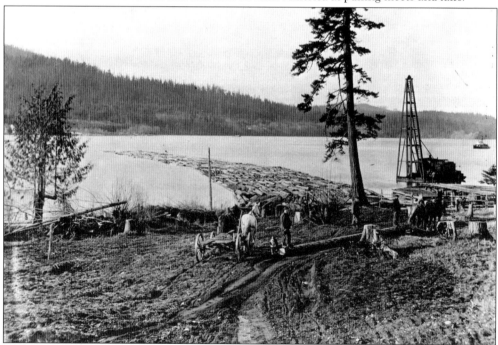

Log booms were collections of logs held for ships. Rafts of logs were towed to mills in the sound. Near Washington Harbor and at the Dungeness Spit, logs were sent over the bluffs and collected at high tide. Once in the water, logs were chained in booms, as shown in this photograph of Sequim Bay.

Port Discovery Mill began logging the Dungeness Watershed around 1858. Oxen teams hauled logs down tallow-greased skid trails constructed through the riparian corridor on the riverbank. By 1882, the mill had closed, and land was available for sale in smaller parcels. Hamilton Lipsett and Charles Seal brokered sales that facilitated the further settlement of the area by farmers and independent logging operations.

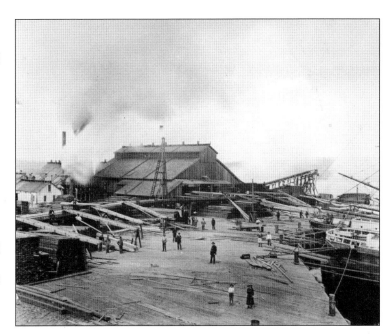

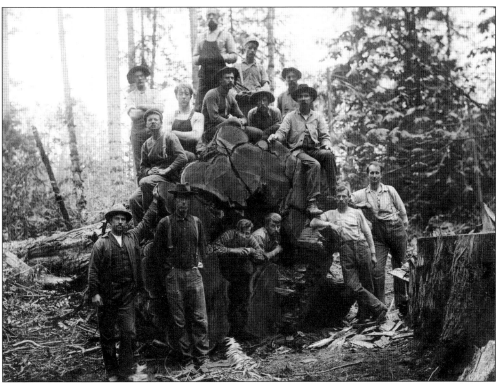

This Joseph McKissick photograph was taken on the Heath property in Dungeness and shows 15 loggers on and around a felled tree. Men often logged for part of the year to buy supplies such as seeds, tools, and nails to maintain their claims. Landowners received income from the timber sale, and the timber's value was deleted from property tax assessments.

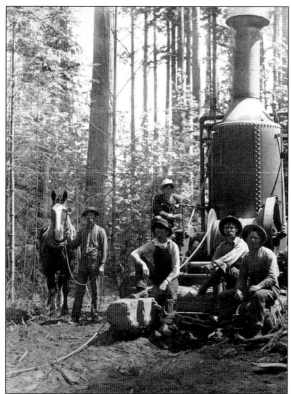

Roy Long's logging crew poses by their donkey engine. From left to right are (first row) Don Kramer, Charlie McDougall, and Frank Swanson; (second row) Bill Stroup (with horse) and Roy Long. Steam donkey engines were first adapted for logging by John Dolbeer in 1881. The engine was modified from a ship's auxiliary engine that wrapped cable around capstans to load cargo or haul nets.

When engaged, the donkey engine wrapped a cable around a gypsy head (spool) to ground-lead (pull) logs to a landing. The engine sat on a sled and could be winched to a new site. The advantage was that the engine pulled logs upslope on steep terrain unsuitable for oxen, thus allowing loggers to reach trees in less accessible sites. The donkey engine changed logging operations throughout the Pacific Northwest.

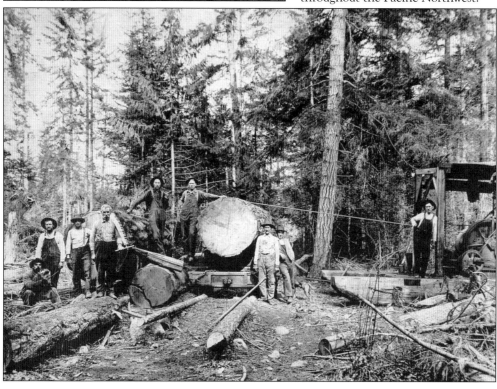

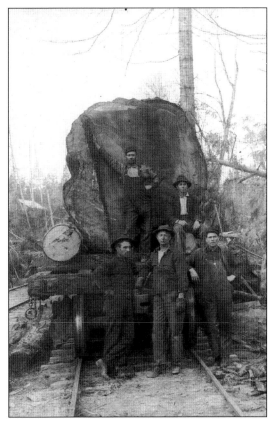

William Long opened a mill in 1902. Roy and Robert Long owned two mills, beginning about 1906. Shown at right are Bill Stroup, Roy Long, Don Kramer, Charlie McDougall, and Frank Swanson (standing on log). In a 1912 *Sequim Press* advertisement, The Long Lumber Company advertised "Dry kilns and green lumber, fruit boxes, door window frames sashes, turned porch posts and spindle." Roy Long's logging crew is shown below. In 1905, a railroad spur about five miles long was built near the Dungeness River, which facilitated the transport of timber to local mills. The 1906 San Francisco earthquake increased demand for manufactured wood products, such as shingles.

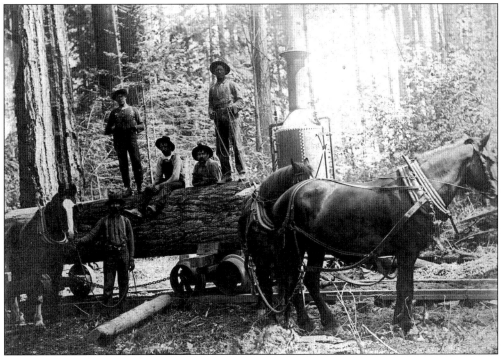

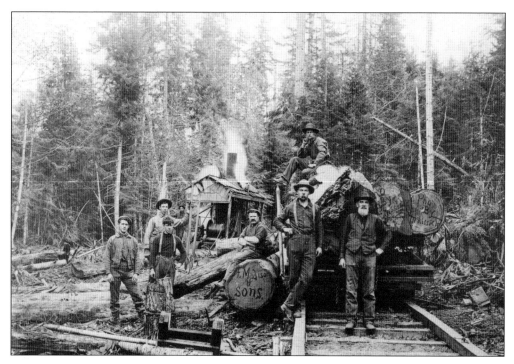

The Madison family owned one of the early mills and logged in the Dungeness watershed in the early 1900s. The Madison & Sons logging crew is shown above near Dungeness. The photograph below shows a pole road at a logging operation near Sequim. Logs were laid out like a railroad. Oxen, horse teams, or an engine would then pull a flatbed car with specially cupped wheels. The pole road was built to extend into the timber stand from a landing near the river. Logs were taken out on the pole road and floated down the river to a boom site.

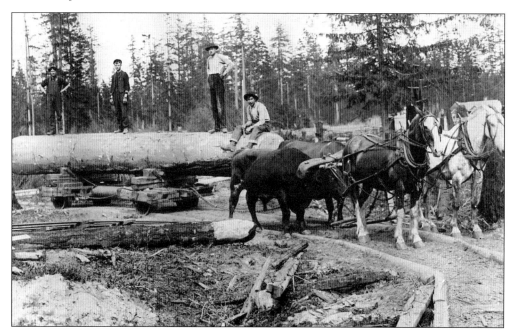

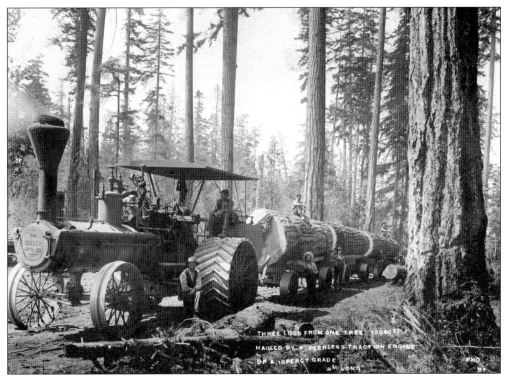

Although the Port Discovery Mill took the largest and most easily accessible timber, there were still large stands of old growth in the Sequim-Dungeness area. The photograph above is inscribed, "Three logs from one tree, 12,060 feet; hauled by a Peerless Traction Engine up a ten percent grade; William Long, Sequim." From left to right are William Long, Jack Long, Frank Swanson, William Wilder, Link Long, Guy Long, and Fred Long. Joseph McKissick has inscribed his name on a log facing the camera to the left of the foremost tree. The photograph below is also from Long logging operation.

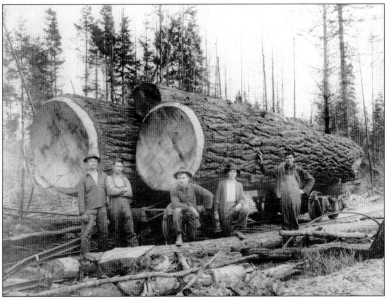

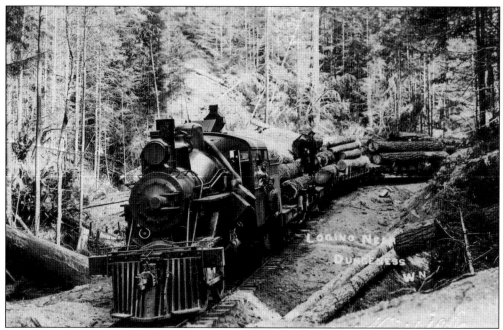

This Joseph McKissick photograph is inscribed "Dungeness, Washington" and is one of the few identified photographs of a logging train. The photograph below is also from Dungeness and shows a steam donkey in operation. Logs that have been skidded to the landing are being hoisted with cables and blocks onto the rail cars for further transport. A 1917 issue of the *Timberman*, a logging industry publication, states, "The Carlsborg Mill and Timber Company has closed a deal with the Dungeness Logging Company for practically all the timber between Port Angeles and Sequim, and also gains access to the timber of the National Forest by way of McDouglas Creek."

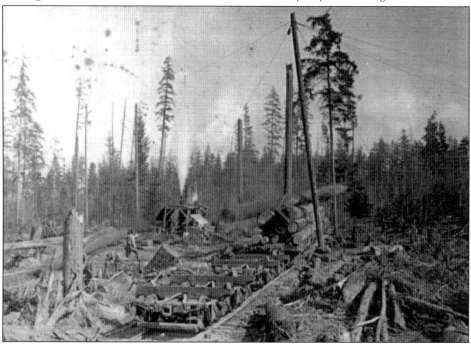

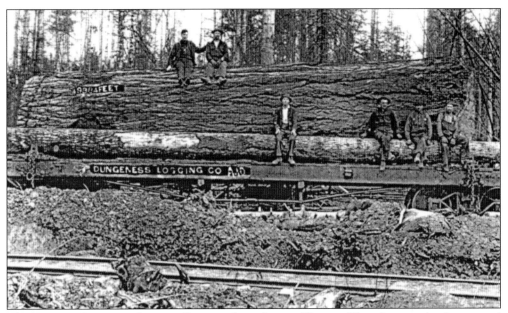

The Peterson's Dungeness Logging Company logged west of Sequim. This photograph taken around 1910 was inscribed, "Dungeness Logging Co., 9884 feet." Until 1920, the company supplied logs to the sawmill that became the Elliot Bay Mill Company. The three Peterson brothers and Craig Spenser later formed the Eagle Gorge Logging Company until their holdings were exhausted in 1955. It was thought to be the last all-railroad operation in the state.

After the usable timber was harvested, the land had to be cleared of stumps for planting or construction. Several steps could be expedited by blasting with dynamite. Reports from the *Sequim Press* mention that the stump removal process could be heard throughout the area. This photograph shows land being cleared in Sequim. Heavy, hand-operated stump pullers were also used.

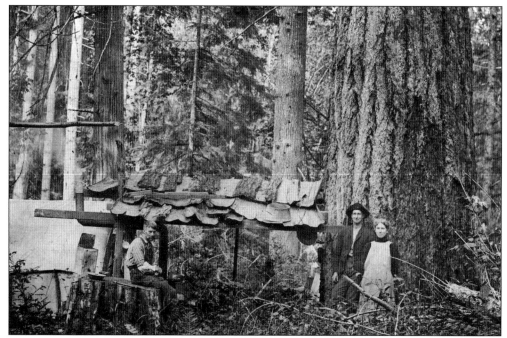

From left to right, Harry Heath, Ray Maxey, and Ethel Sprague Maxey are cutting shingles for the Cougar Mill near Sequim in 1905. Several large shingle mills operated locally beginning in the 1890s, and shingles became one of the area's largest exports. The *Sequim Press* in 1911–1912 made note of many outgoing shipments from Port Williams exceeding one million shingles. State export records for this era show shingles shipped worldwide.

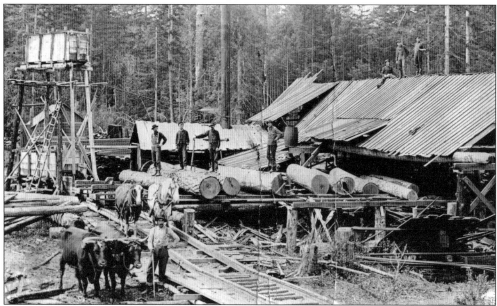

Pictured here is J.R. Long's Riverside Logging Company in the Dungeness watershed. The Riverside district referred to the area now accessed by River Road. Jack Long sold the mill in 1913 to S.W. Bigelow and Fred Schott. There were mills throughout the region. Joseph Keeler built a large mill in Sequim, but most were smaller operations that moved after the timber was harvested.

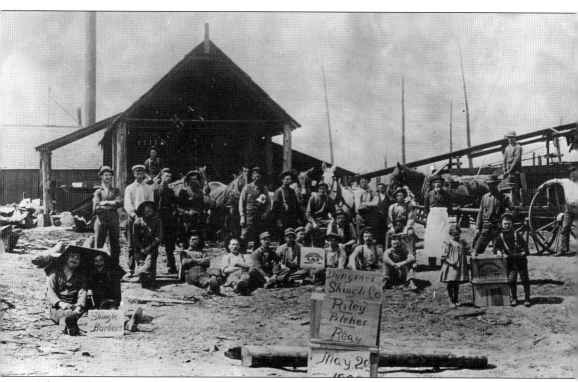

A box in the foreground reads, "Dungeness Shingle Co.; Riley, Pileher, Reay; May 20, 1900." Two men under a parasol hold a sign reading "Shingle Barbers." In 1922, the *American Lumberman* noted, "At least a dozen mills at Port Angeles and Clallam County have made arrangements with a Seattle shipping firm under which 10,000,000 green shingles a month will be shipped from this port by water to the Atlantic Coast."

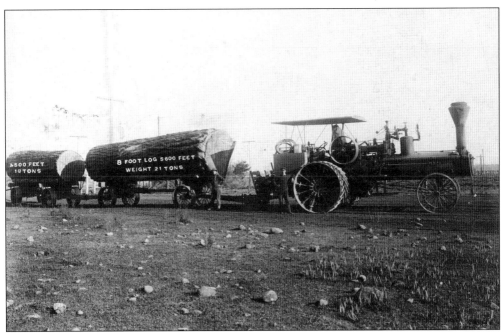

The photograph above is inscribed, "8 foot [diameter] log, 5600 feet [estimated milled board feet], weight 21 tons," and the second section is marked, "500 feet and 18 tons." William Wilder drove along Washington Street in his Peerless steam tractor en route to Washington Harbor to drop off his logs regularly. From there, the logs were towed to Everett. Charles Seal's Sequim Trading Company can be seen at the corner of Sequim Avenue in the background below. Logging remains integral to the Olympic Peninsula economy. The annual Sequim Irrigation Festival Logging Show in May provides the public with a demonstration of the equipment and well-honed skills used in local forests since the 1850s.

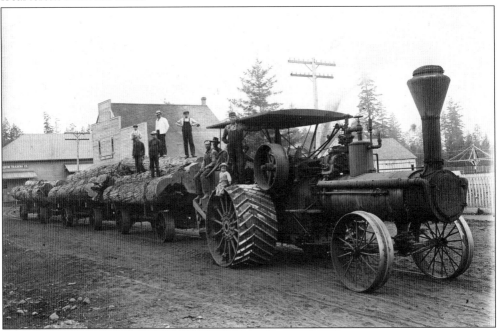

*Four*

# RISING TO THE TOP
## DAIRY FARMING AND AGRICULTURE

The opening of the first irrigation canal head gate from the Dungeness River in May 1895 is celebrated annually at Sequim's Irrigation Festival, the oldest festival in the state. By 1910, according to the Washington State Bureau of Statistics, 5,000 acres of farmland were being irrigated and the potential usable area of the entire irrigation district land was estimated at 20,000 acres.

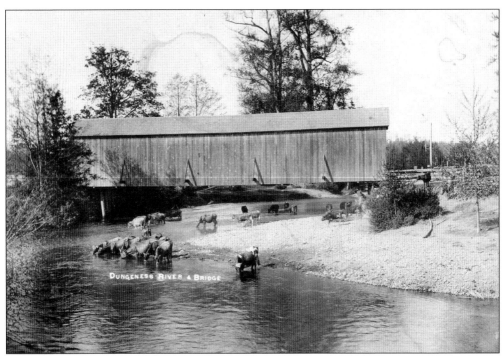

Alonzo Davis advertised his Jersey cows in the 1893 *Dungeness Beacon*. Before settling near his parents in Dungeness, Davis had worked the Yuba and Sacramento Rivers during the California Gold Rush and prospected in the Cariboo Gold Rush. Other farmers, including his brother, Hall Davis, raised Holstein-Fresian cows. Both dairymen imported registered stock for breeding. Joseph McKissick's photograph above shows Jersey cows near the covered bridge close to the Dungeness Schoolhouse. In 1893, the *Dungeness Beacon* stated, "Dungeness is the best location in the state for a creamery. There are five dairies, averaging 100 cows each . . . and every ranch has from five to twenty cows. The Groveland Improvement Co. offers good inducements for the establishment of a plant on their townsite . . . located in the center of farming district and [near] the only wharf to deep water."

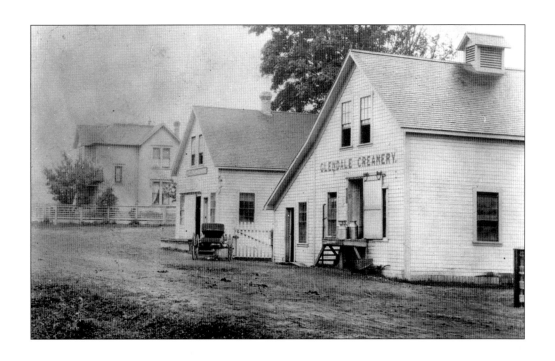

In 1899, a total of 11 dairies in Dungeness received official brands and numbers by state dairy commissioner E.A. McDonald. The state also passed pure food laws protecting against imitation. Butter laws required oleomargarine to be colored pink and a "conspicuous notice" posted in restaurants serving oleo. Violators of the dairy regulations faced fines and imprisonment. In 1902, the Glendale Creamery of Chimacum opened in Dungeness. Under the management of David Troy, the creamery provided a market for farmers from the Quillayute to Quilcene. Bell Jefferson, the Jersey cow on the letterhead below, produced 21.4 pounds of butter in seven days. Part of the creamery still stands.

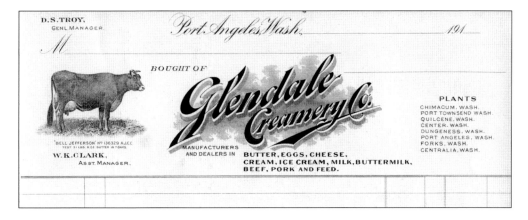

69

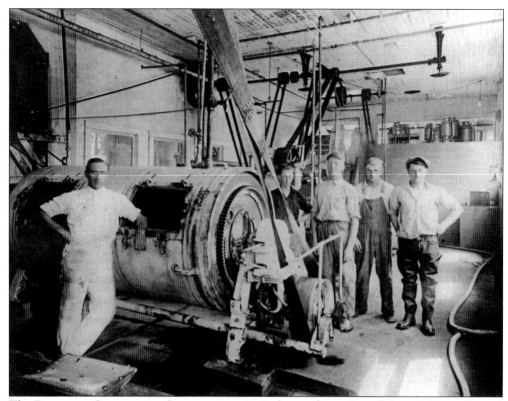

The Dungeness Co-operative Creamery interior is shown above. From left to right are Conrad Kirner, unidentified employee, Jim Mapes, and Merton Mapes. Creamery director for several years, Jim Mapes was also port commissioner for 12 years and director of the Dungeness School District. The certificate below from the Dungeness Co-operative Creamery was issued to Roy Stone in 1913 and signed by E.F. Gierin. Dairy production had evolved since butter was processed and shipped by individual farms; by the 1910s, marketing was handled by the creameries. Co-operatives allowed farmers as a group to set a viable price for their product.

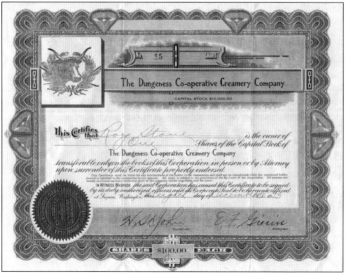

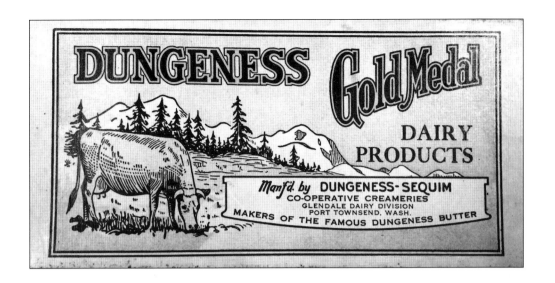

The butter carton above is from the Glendale Division of the Dungeness-Sequim Co-operative Creamery. By 1912, the original creamery had reorganized into a cooperative creamery. In 1929, George Fitzgerald Sr. was the chief executive officer in Seattle for the entire creamery operation. During that time, the creamery expanded to process cottage cheese, sweet cream, whole milk, cream cheese, and ice cream. Fitzgerald was a large landowner, farmer, and member of the S'Klallam Tribe. He is shown below with one of his Jersey cows. (Above, photograph by Katherine Vollenweider; below, courtesy of the Jamestown S'Klallam Tribe, Fitzgerald-Chubby family collection.)

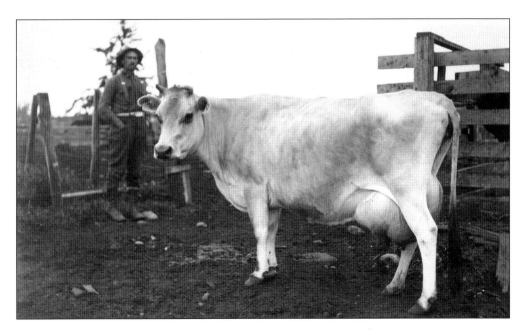

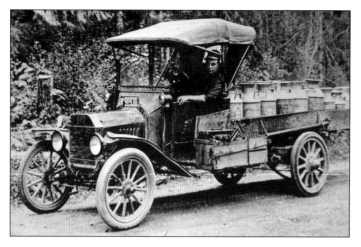

This is one of the early creamery trucks in the Dungeness area around 1914. As marketing and processing techniques improved, local cream was separated at each farm, and trucks delivered daily to the creameries. Milk was difficult to ship without refrigerated holds on steamships, so butter and cheese were the preferred exports.

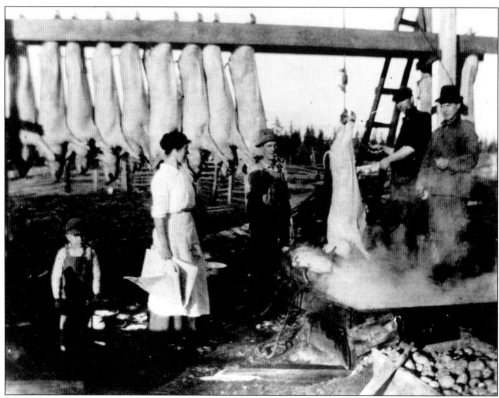

Pigs were fed skim milk, a dairy byproduct. In the 1912 *Dairying, Poultry and Stock Raising in Washington*, Arthur Cays of Dungeness stated that he fattened hogs on wheat, peas, barley, and one gallon of skimmed milk for each 25 pounds of body weight. Pigs gained two and a half pounds per day on this diet. Dressed hogs, like those being processed here in Dungeness, were a consistent export from Dungeness via steamship.

In this 1905 Dearinger photograph, Charles Carpenter and Earnest Webster harvest strawberries in Dungeness. The average Olympic Peninsula farms were small with varied microclimates, unlike the plains of eastern Washington. A survey of over 80 claims made under the terms of the Forest Homestead Act of 1906 reported homesteaders grew hay, potatoes, clover, hops, apples, wheat, and strawberries. The Washington Harbor Cannery processed strawberries for export.

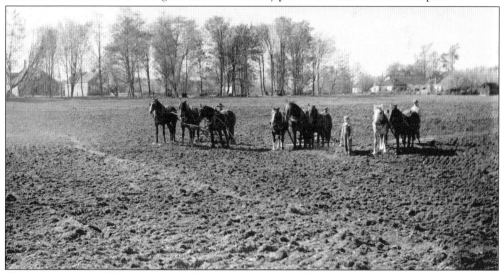

Shown here is a field being harrowed by a horse team. William Ward of Dungeness was quoted in the 1900 *Western Creamery* publication saying, "One acre will pasture two cows all summer and another acre will raise hay enough to feed two cows in good shape all winter. I have never known any disease among cows here. Horses here live to a great age, and with proper care are very healthy. In fact, all kinds of stock are very healthy here."

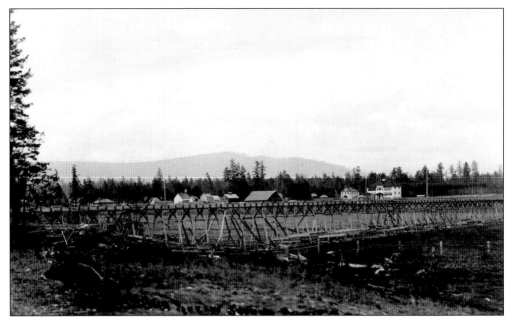

Despite anecdotal accounts of the proposed Sequim irrigation project's efficacy being doubtful, local papers from the time discuss irrigation's success in other states, and the technology itself was thousands of years old. Sequim and Dungeness were cosmopolitan communities with thriving trade and cultural exchanges and access to world news through print and wire services. Shown west of the flume are the Methodist church spire and two Sequim school buildings.

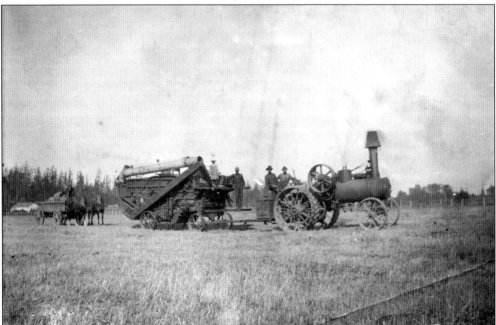

By 1912, the *Sequim Press* reported a threshing machine had arrived by steamship for Cays and Collins. George Fitzgerald Sr. also had one of the valley's early threshing machines. In 1913, Arthur Cays averaged 111 bushels per acre with a range of 75 to 140 bushels per acre. This 1913 photograph shows a threshing machine and steam tractor.

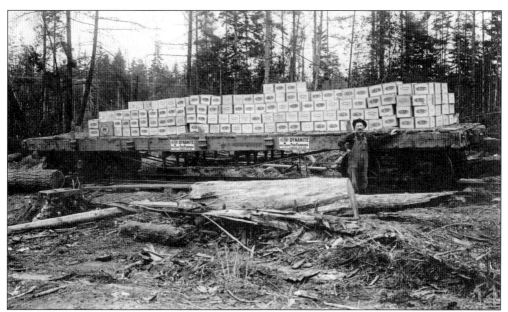

The 1912 Bureau of Soils field operations publication described Sequim's subsoil as "more gravelly than the soil, being in places little more than a mass of cobbles and gravel, which range from a few inches to a foot or more in diameter." Gunderson sold DuPont Red Cross Dynamite, touted to break up clay hardpan, kill grubs, and convert soil to loam—overly ambitious claims—though blasting certainly expedited stump removal.

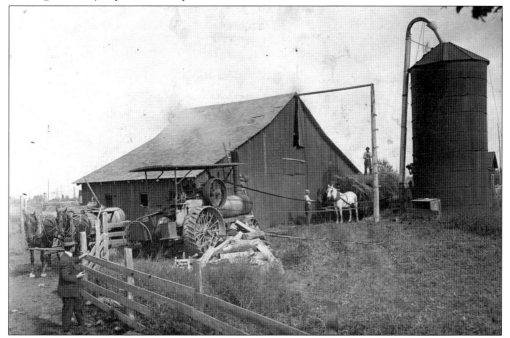

In 1913, the *Sequim Press* reported a "steam barge landed about 20 silos at Port Williams . . . for dairymen around Sequim and Dungeness. The silos will provide green feed for cattle during the winter season and keep a lot of the money at home that is now paid out for feed shipped into the county."

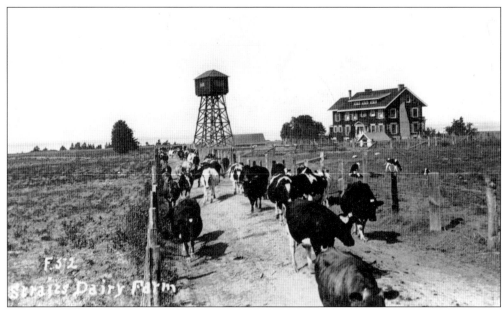

The photograph above shows Holstein cows at the Straits Dairy (Graysmarsh Farm). In 1911, an article in the *Sequim Press* noted that, "The cool summers and even winters—with abundant grass and forage . . . made the area desirable for dairying. . . . Jersey, Holsteins, and Guernseys are used and dairymen raise most of their own hay although grain is shipped in from other parts of the state. . . . The creameries in 1910, paid out $250,000 to farmers and manufactured 1,790 pounds of butter a day, besides selling ice cream and cream. The yearly output of the Dungeness Creamery is over 300,000 pounds . . . Port Williams 200,000. In the Dungeness District, there are over 2,000 cows. About 400 men and families are engaged in farming and dairy lands sell at $250 to $300 an acre according to improvements and irrigation." The photograph below shows a local barn under construction.

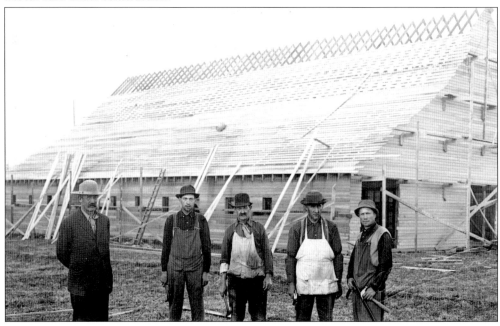

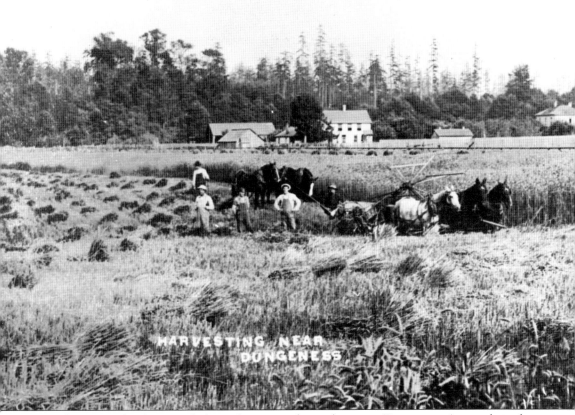

HARVESTING NEAR DUNGENESS

Joseph McKissick's photograph shows farmers scything wheat near Dungeness. An article in the February 1861 *Washington Standard* stated that, in 1858, Samuel Matney shot a wild goose near the Butte Mountains in California. He saw unidentified grains in the crop and believed them to be wild wheat. Saving and planting them the following spring, he moved to the Pacific Northwest before they ripened but took a few unripe kernels plucked from the heads. Calling on John Donnell of Sequim, he had a parcel holding the "identical wheat that had been produced from seeds taken from the wild goose's crop. He gave 15 kernels to Mr. Donnell, who planted them last year, and has now two thousand kernels which he will plant this spring, and save the crop for seed until he can increase it enough to sell to others." The strain ripened very early and grew to six feet high with 10-inch heads. Donnell called it "Uncle Sam Wheat" after Matney's nickname.

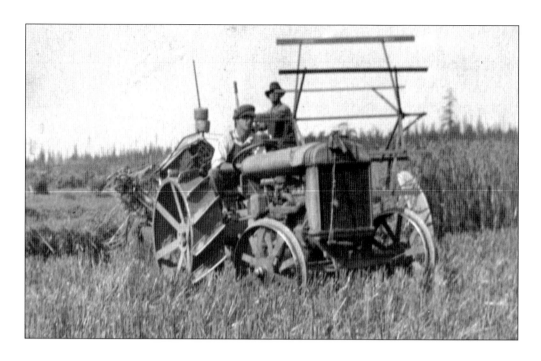

Local farmlands continually met or exceeded statewide production of crops. The report titled *North Western Washington: Its Soil, Climate, Production, and General Resource* (1877) stated that New Dungeness wheat averaged 40 to 50 bushels and up to 60 bushels per acre. Oats averaged 50 bushels, with occasional yields of 100 bushels per acre. In 1892, the *Dungeness Beacon* reported 247 acres of wheat yielded between 65 to 86 bushels per acre; oats ranged from 55 to 60 bushels per acre; and potatoes from 200 to 400 bushels per acre. The McKissick photograph below is inscribed "Oat and pea hay, six tons per acre, Sequim Washington."

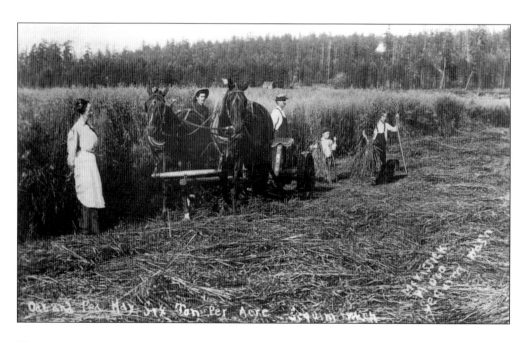

The photograph above shows a full irrigation ditch flowing during a local threshing operation. Bundles of dried wheat were fed to the thresher. The grain was separated and cleaned before being stored in bags or in a granary. The straw and chaff were used in the barn and stables for bedding. A steam tractor powers the threshing machine. In 1911, the Port Townsend *Leader* reported that the Sequim prairie irrigation projects had engendered other groups, such as the Dungeness Irrigation Company. The certificate below is for 30 shares costing $6 each and signed by Arthur Cays and J.E. Hooker in 1913. Irrigation companies monitored and maintained the ditches and negotiated water usage with the state and other companies.

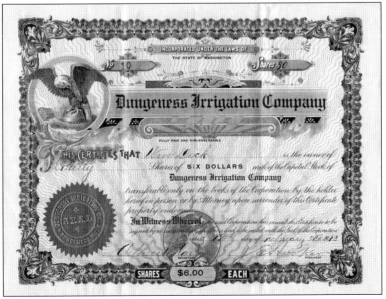

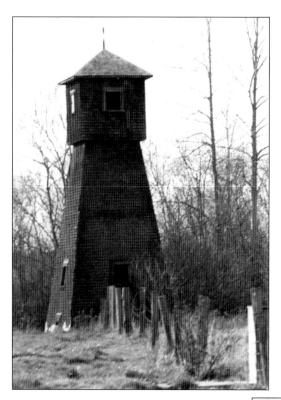

Dairy farming was intrinsic to the settlement and development of the area, creating a pastoral lifestyle for residents. However, work on the dairy farms was never-ending, with 4:00 a.m. and 4:00 p.m. milkings year-round, despite the weather, recessions, and the ambiguity of markets. This photograph shows the Gierin Farm water tower, built about 1907.

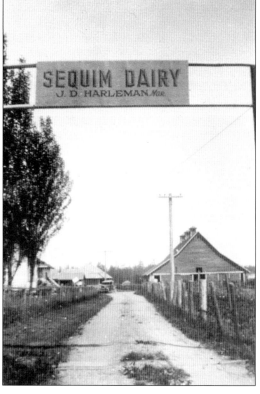

A favorable climate and opportunity for land ownership facilitated dairy farming, but as time passed, fewer farms remained in production. Concurrently, overall milk prices were decreasing, while fuel prices rose. Consolidation into larger farms was common. The emerging era of agribusiness was changing the landscape of the American farm nationwide. This photograph shows J.D. Harleman's Sequim Dairy on Old Olympic Highway.

# Five

# HOME ON THE LONG PRAIRIE
## THE SETTLEMENT OF SEQUIM

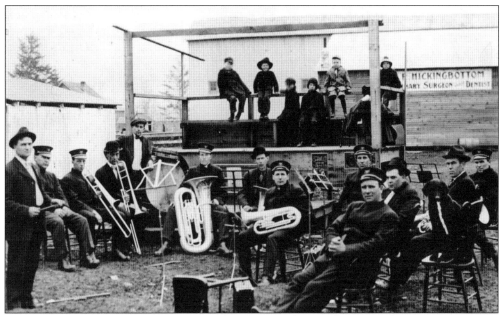

The Sequim Town Band was photographed in the 1920s by Joseph McKissick at many a May Day, Fourth of July, and Decoration (Memorial) Day celebration. A sign reading "Dr. Hickingbottom, veterinarian surgeon, and dentist," is affixed to the livery stable at right. The bandstand was at the corner of Washington Street and Sequim Avenue, adjacent to the livery stable.

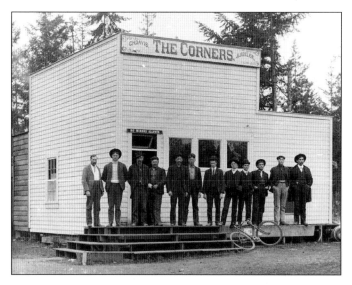

After numerous adventures as a sailor, merchant, Klondike Gold Rush miner, farmhand, logger, and card dealer, Joseph Keeler (far left) moved to Sequim in the early 1900s, opening The Corners saloon with George Davis on Sequim Avenue and Washington Street. His business and engineering skills shaped Sequim as he developed city water, electrical, and telephone utilities. He served as a state senator in 1937 and as a county commissioner.

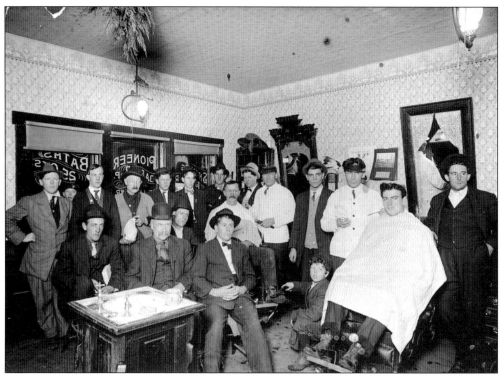

One of Joseph Keeler's first jobs was in Port Townsend as a shoeshine boy. In this highly competitive business, he reputedly outshone his competition by developing an apparatus that could keep inebriated sailors upright during the shine. Here, a young man practices the trade at Everett Fisher's barbershop in the Hotel Sinclair.

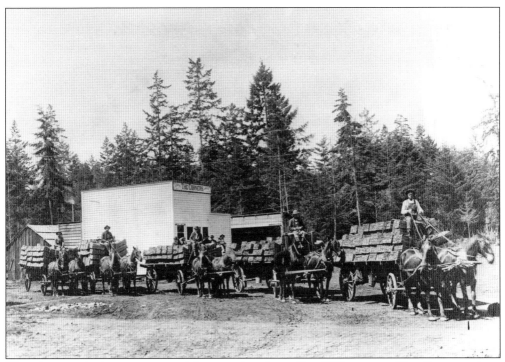

This photograph shows teamsters delivering shingles to Port Williams past The Corners saloon at Sequim's main intersection. Sailing vessels and steamships were the lifeline of the economy, exporting shingles, hogs, logs, potatoes, hay, and seafood while importing farming equipment, sugar, cloth, medicine, rope, and tools. Port Williams and Washington Harbor were the closest ports to Sequim, and steamships arrived daily. The Corners offered a quick quaff en route to the wharf.

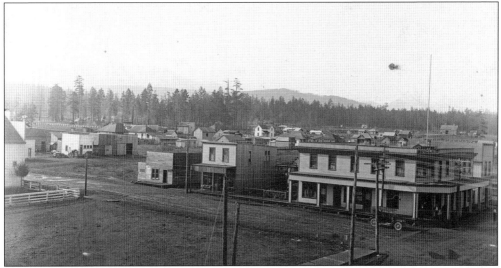

John Dearinger's photograph shows Joseph Keeler's Hotel Sinclair at the southwest corner of Washington Street and Sequim Avenue. The Corners was moved next to the blacksmith shop on Bell Street near Sequim Avenue when the hotel was built in 1908. Keeler's cash store was south (left) of the hotel. Keeler started a mill with his father-in-law, George Priest, where they sawed the wood for the hotel.

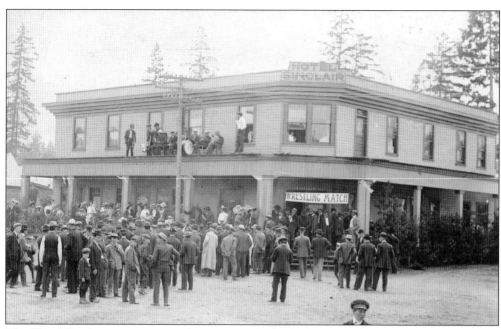

The Hotel Sinclair was an oasis of commerce, with a restaurant, shoe repair service, dentist office, barbershop, cash store, and a bakery with a 250 loaf per day output. Opticians stayed at the hotel periodically to see patients. Joseph Keeler supported baseball teams, horseracing, and other recreational endeavors. Here, people assemble for a wrestling match while the band rests outside the second story of the hotel.

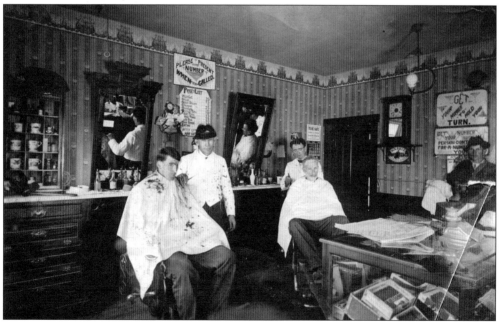

This 1910 John Dearinger photograph shows the barbershop in Hotel Sinclair. Everett Fisher (second from left) came to Sequim in 1901, opening his first shop in 1903. He moved to the hotel in 1908. The shop had gas lighting and offered a variety of services, including a 25¢ shave or haircut, neck massages, 35¢ baths, and the ever-popular 25¢ hair singe.

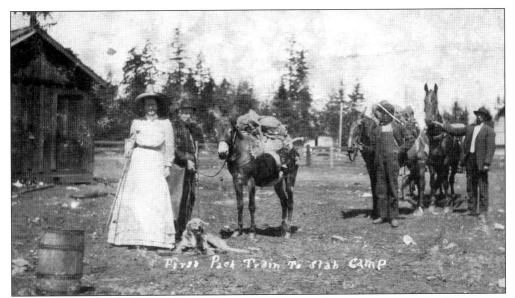

First Pack Train To Slab Camp

Joseph Keeler marketed his hotel and Slab Camp summer cabins to tourists in the Olympics. A 1911 *Sequim Press* article read, "A modern, comfortable, and desirable summer resort, 25 furnished rooms, good table service, 12 miles trail to Olympics. The shortest route for mountain climbers, campers, tourist, and sportsmen, summer camps kept." This photograph shows a pack train at Slab Camp, with Etta Keeler in the lead.

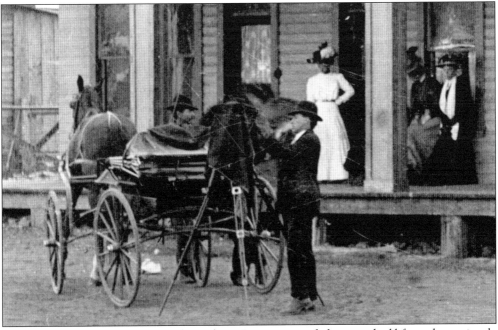

Photographer Joseph McKissick had a studio in Dungeness and photographed life on the peninsula in the 1900s. He often dated and inscribed details on the sides of the glass plate negatives, providing context for his work. He is seen here in front of the Hotel Sinclair with the large tripod needed to stabilize the heavy camera and the black cloth that restricted light during the exposure and film removal.

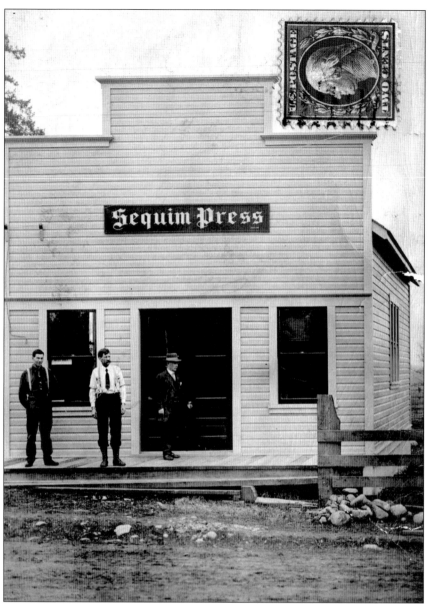

George W. O'Brien's family emigrated from Ireland. At 17, he became a timekeeper at Discovery Bay Mill. He then published the *Port Townsend Call*, and in 1890, established the *Clallam Bay Record*. In 1911, he started the *Sequim Press*. The weekly newspaper had boilerplate pages devoted to world politics, fashion, innovations, inventions, agriculture, natural history, food science, travel, and serialized fiction. Type plates were stamped in steel and arrived by steamship, allowing residents access to current events. Local news, advertisements, and public notices were covered by O'Brien. The office was built in 1911 by George Hart, R.R. Cays, and Charley Cays. O'Brien became an attorney, land agent, notary public, Sequim city clerk, and a US commissioner. He was an enthusiastic participant in the building of Sequim, and his obituary noted that he "worked for civic improvements and his share in the modernizing of the prairie city was great." O'Brien used his "voice and his pen for progress" and, along with Joseph McKissick, left the Sequim and Dungeness area a rich compendium of history.

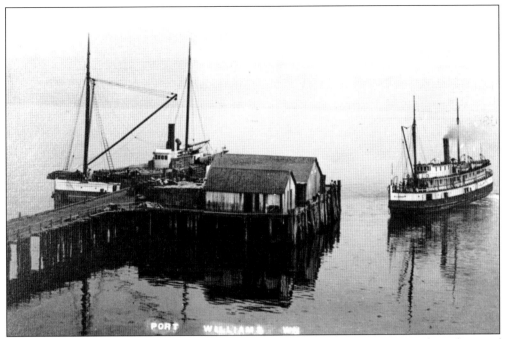

Merchandise and supplies for all of Sequim's livelihood and endeavors came in through one of four ports: Port Williams (pictured), Washington Harbor, Dungeness, or the wharf at Old Town. During the early days of Sequim's development, roads were quagmires during rain, dusty during the dry season, and rutty in between. People, supplies, and equipment arrived via canoe, ship, or scow, but travel by steamship to Victoria, Seattle, or Portland could be made in a day.

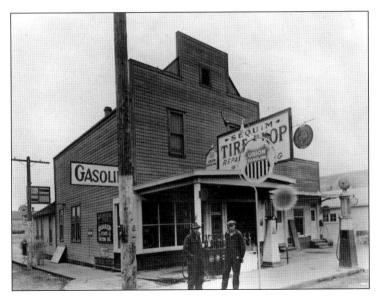

This building formerly on Sequim Avenue and Washington Street was the first location of the Sequim Trading Company prior to the larger store being built across the street, which still stands. The Sequim Masonic Lodge No. 213 met upstairs. Charles Seal was a charter member of the lodge and its first grand master. The store was later used for furniture sales and then converted much later into a gas station.

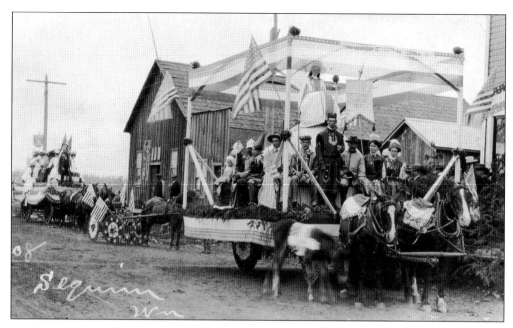

McKissick's July 4, 1908, photograph shows the Brotherhood of American Yeomen Lodge 1210 with arrows upright west of Farmers Hall, where the Veterans of Foreign Wars post is today. By 1910, this was the Grand Old Army Hall. The *Sequim Press* listed meetings for the following organizations: GAR Veterans Post 124, Royal Neighbors Evergreen Camp 658, Washington Grange Home Lodge 56, Rebecca Lodge, Women's Veteran Corps, Women's Relief Corps, and the Brotherhood of American Yeomen Sequim Prairie Lodge 1210. The Yeomen began in 1897, becoming Mutual Life Insurance Company in 1932. Below is the Sequim Lodge of the Modern Woodmen of America at the hall. Founded by Joseph Cullen Root in 1883, the organization promoted patriotism and civic responsibility and provided financial security for members through insurance.

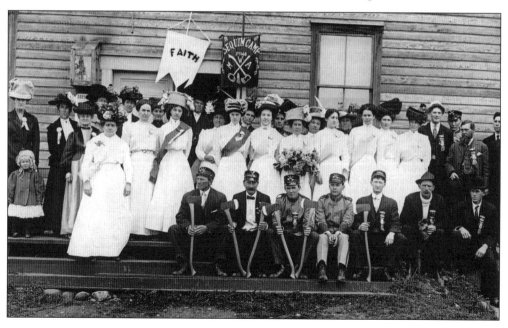

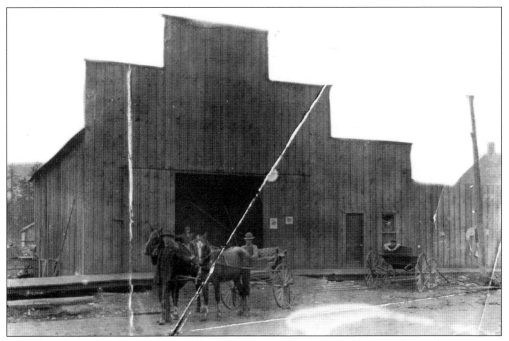

This early photograph shows a livery stable believed to be owned by Stanley and Roy Stone, located on the south side of east Washington Street, on the future site of the Lehman's shop. The photograph was found in a Sequim High School sociology class report written in 1942 by Margaret Eberle and Elsie Gilbert.

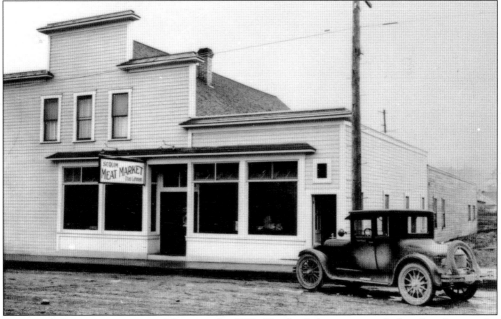

Some early businesses prospered for years. In 1911, Charles Lehman opened a butcher shop in the Hotel Sinclair. By 1912, the *Sequim Press* reported Lehman was working on a shop and residence on the south side of east Washington Street. The Sequim Meat Market and the subsequent grocery operated on the site until the 1990s.

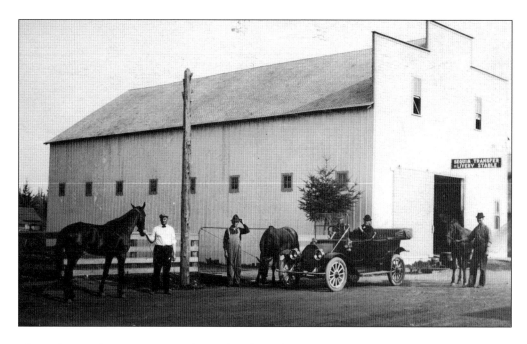

The evolution of transportation is depicted in these photographs taken outside the Sequim Transfer and Livery Company on south Sequim Avenue across from the Hotel Sinclair. Horse-drawn buggies and wagons were essential for deliveries of passengers, mail, and merchandise brought by steamship to Port Williams, Washington Harbor, and Dungeness. Owners Roy Greenfield and Ed Green had a buckboard wagon stage (below), passenger buggies, horses for sale, and an auto for hire by 1912. In 1913, George Priest and sons had purchased the business. The Olympic Livery, Feed & Exchange Barn, owned by P.W. Cays and sons, was located southwest of the Hotel Sinclair.

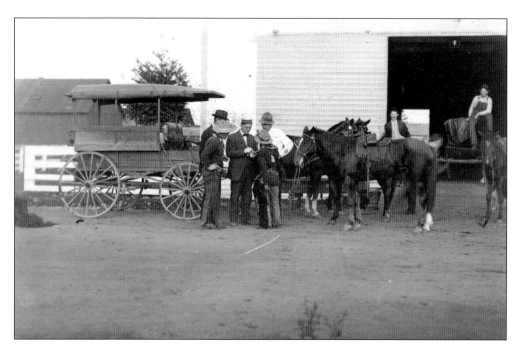

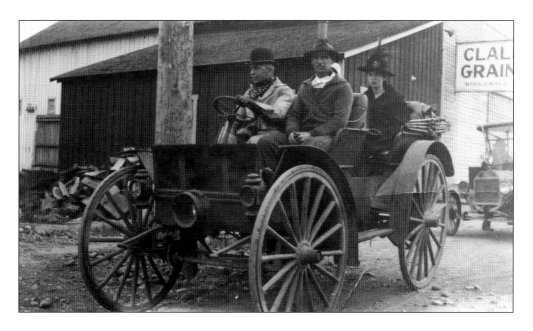

The Clallam Grain Company was located at the Sequim Transfer & Livery in later years and sold feed, flour, seed, and hay. Shown above is a 1908 or 1909 Model A International Harvester high-wheeled runabout with a two-cylinder, 14-horsepower engine. The frictional transmission, 84-inch wheelbase, and solid tires were suited to local roads. Advertisements for this automobile read, "This type of vehicle has been serving the country, town, and rural people for years, and there is no reason why a simple motor vehicle of this type cannot serve them in the future." The photograph below shows an early motor stage owned by the Sequim Trading Company outside the Sequim Transfer & Livery Stable.

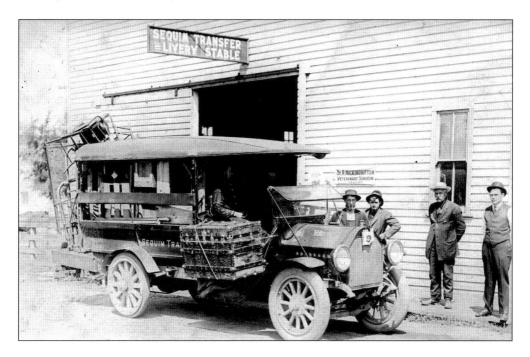

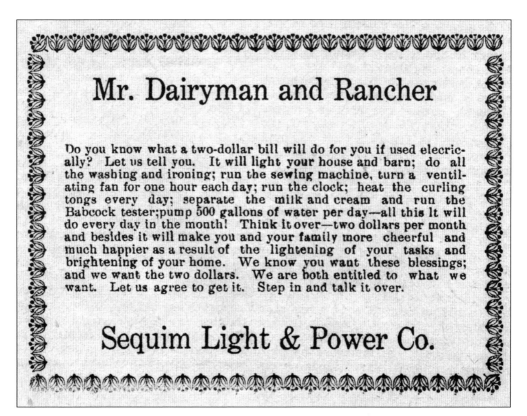

# Mr. Dairyman and Rancher

Do you know what a two-dollar bill will do for you if used elecrically? Let us tell you. It will light your house and barn; do all the washing and ironing; run the sewing machine, turn a ventilating fan for one hour each day; run the clock; heat the curling tongs every day; separate the milk and cream and run the Babcock tester; pump 500 gallons of water per day—all this it will do every day in the month! Think it over—two dollars per month and besides it will make you and your family more cheerful and much happier as a result of the lightening of your tasks and brightening of your home. We know you want these blessings; and we want the two dollars. We are both entitled to what we want. Let us agree to get it. Step in and talk it over.

## Sequim Light & Power Co.

The advertisement above is from the *Sequim Press*. Joseph Keeler installed telephone lines and put the switchboard in his Washington Street house. By the 1910s, customers had one number for local calls and another for calls outside the network. In later years, Keeler forged agreements with existing companies in Port Angeles. Electrical lines were on the south (left) side of the street, as shown in the photograph below, which looks west down Washington Street past the intersection of Sequim Avenue.

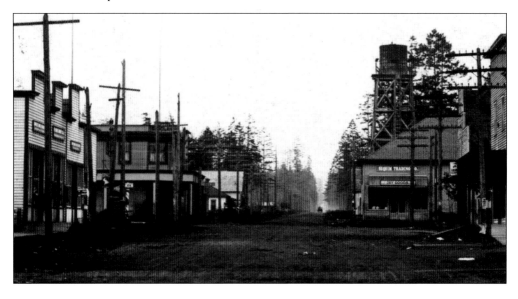

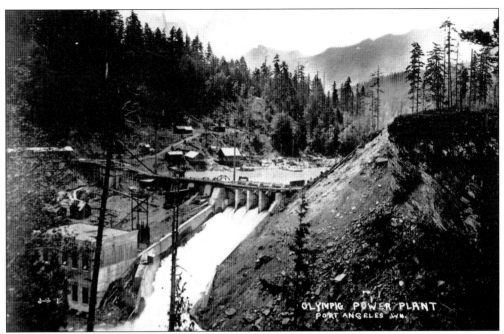

By 1911, seven strands of copper wires carried 66,000 volts of power from Olympic Power Plant on the Elwha River. In 1917, Joseph Keeler's Sequim Light & Power Company provided six 10-watt incandescent lamps and a 250-watt streetlight for $2.10 per month, dusk to midnight. Keeler promised "due diligence to give . . . first-class service" unless "failure was caused by fires, strikes, the elements, or any other unavoidable cause."

Joseph Keeler ran a four-horsepower gas engine to pump water from his 200-foot well at the hotel across the street to the 10,000-gallon Sequim Trading Company water tank. He was granted the right to lay pipe and conduit and operate the water system for public use for 25 years. The Babcock Building (left) still stands.

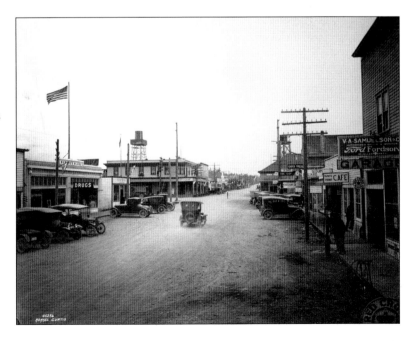

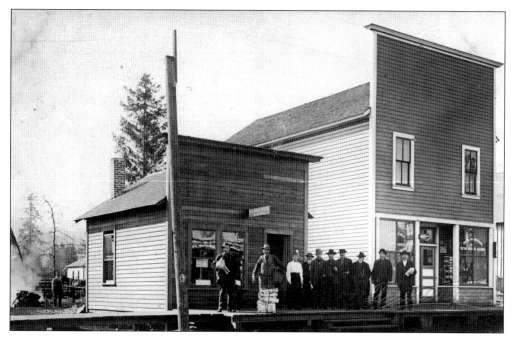

Steamship companies competed for mail contracts to bring mail packets to the towns along the straits. The ships off-loaded the mail pouches at Port Williams and Dungeness to be transported by wagon to the local post offices. Shown are two of Sequim's post office buildings. The post office appears to have misassigned the name "Seguim," but it was never in ubiquitous use, as "Squim" and "Sequim" were also used concurrently. Another common name was "Long Prairie." By 1889, Sequim appears spelled as it is today on census forms. Clallam had numerous variants as well; Callam and Clalam are two.

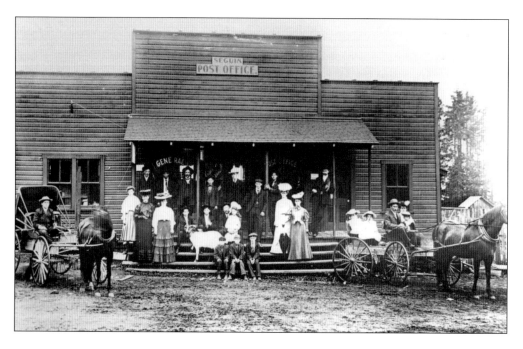

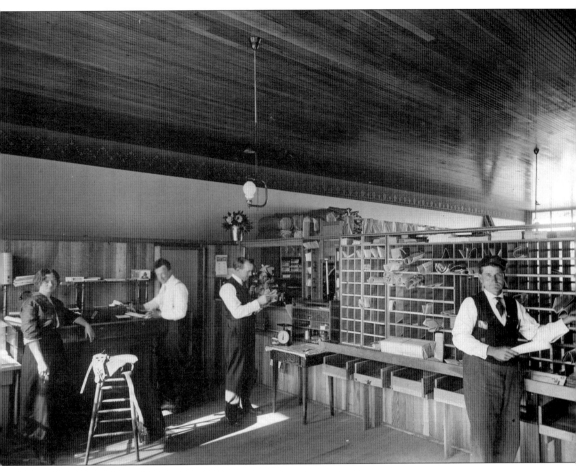

Jens Bugge (far right) worked for his brother Hans before opening Bugge Mercantile and the post office inside. He was Clallam County treasurer, fire chief, mayor, and city council member. He belonged to the Naval Lodge of Elks, Olympic Chapter of Sons of Norway, Port Angeles Kiwanis, Olympic Knife and Fork Club, and Order of Amaranth, and was a charter member of the Masonic Lodge. Special honors occurred in 1912, when the post office became a Postal Savings Bank, the third in Clallam County. Later, the office sold and canceled over $250 in stamps for three consecutive quarters, thus justifying a salaried postmaster position. The photograph below shows the post office when it was inside of Jens Bugge's store on the north side of east Washington Street.

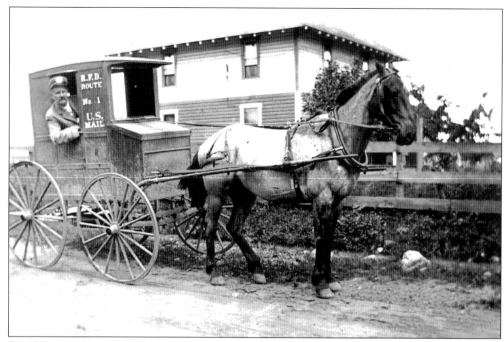

Rural Free Delivery, a cause supported by the National Grange of the Order of Patrons and Husbandry, began locally in 1906. Fred Waldron made the daily journey to deliver mail. He placed a notice in the *Sequim Press* kindly asking residents to purchase stamps rather than continue placing loose coins in their mailboxes. His horse Bess (above) once saved Waldron from a falling tree by her startled reaction.

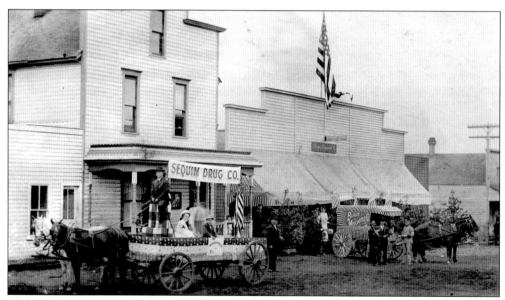

Clubs and organizations built elaborate floats for parades. The Sequim Drug Company float is in front of the Grant Hotel. The Bugge Mercantile Company and its float are to the right. These buildings were on the west side of east Washington Street. The Keelers operated this hotel before building the Hotel Sinclair.

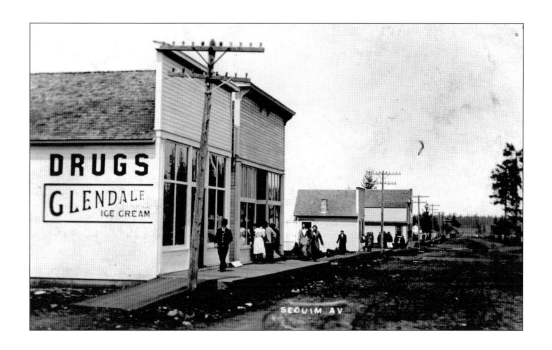

The McKissick photograph above looks north on Sequim Avenue. The Sequim Drug Company (left) was owned by Frank Babcock, who advertised in the *Sequim Press*, "Drugs, patent medicines, cigars and salmon eggs, magazines, and Edison records." He later built the Babcock Building (below right) on east Washington Avenue. Babcock was the second mayor and a graduate of the University of Washington's College of Pharmacy. The photograph below looks east on Washington Avenue. The Knight-Godfrey Mercantile Company was located to the left of the Babcock Building. The cemetery, now Pioneer Park, is slightly visible in the background, to the left of the tree.

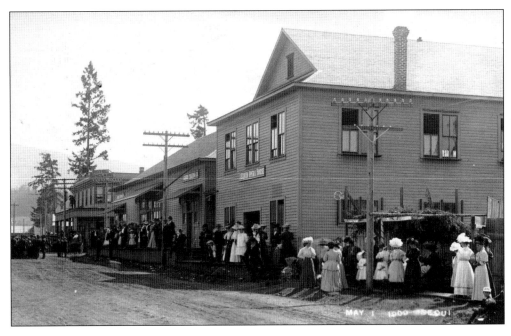

Charles Seal's Sequim Trading Company, which is still standing, and Joseph Keeler's Hotel Sinclair across the street formed a central gathering place for Sequim. The Sequim Opera House (above right) was built for Carolina Seal in 1907 and hosted school events and recitals. Cultural patrons of Sequim joined the nationwide Lyceum League, which paid for traveling oratories, musical programs, and plays. This literary group was a predecessor to the Chautauqua Institution. In 1912, George Sherbourne and George Dearinger showed motion pictures there for two-hour shows, with two changes a week; admission was 10¢. Titles were *Eugenics at Bar 'U' Ranch*, *Bridget, The Flirt*, and *So Shall You Reap*.

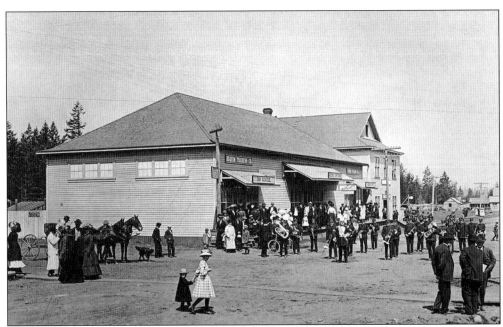

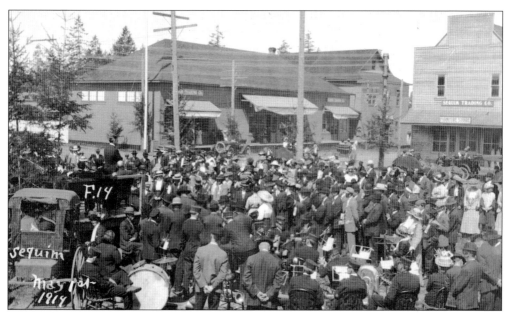

When Charles Seal sought a clerk in 1906, he wrote that the job "could not be more varied. It is simply anything and everything. We handle all kinds of merchandise that the farmer, fisherman, logger, or shingleman could want." His former clerk earned $60 per month, free rent, and goods at cost plus five percent. Above, the Sequim Town Band is shown at the May 1, 1914, celebration. From left to right are the Sequim Trading Company, the Sequim Opera House, and the Sequim Trading Company Furniture Store (meeting place for the Masonic Lodge). Below is the interior of the Sequim Trading Company. From left to right are Jilson White, Sequim's first mayor; Clinton McCourt, the first fire warden; and Bessie White.

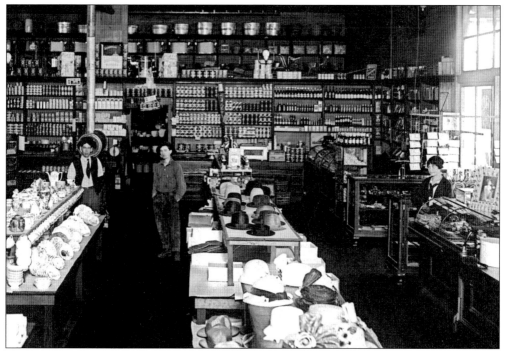

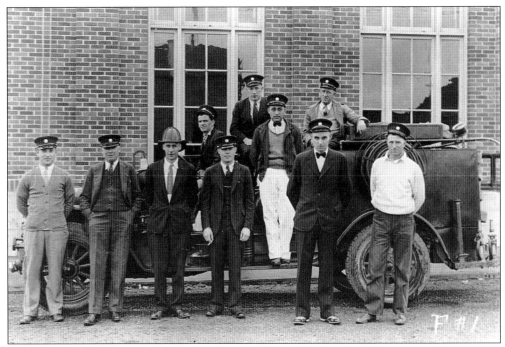

Retired fire chief Stephen Vogel recounts that the first fire department was organized in 1914 and was called the Sequim Fire Company. They used a manual hose reel, pulled by six to eight firefighters. The Sequim Fire Department was reorganized under the Washington State Board of Firefighters on March 23, 1923. Jim Otto was the first fire chief under the reorganized bylaws. Prior to that time, volunteer bucket brigades fought local fires.

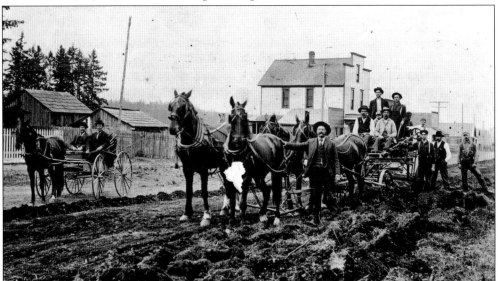

Road building and maintenance were essential for commerce. The roads deteriorated during the rains, and heavily laden wagons created ruts, making it difficult for the lighter buggies to travel safely. The dust and mud were eventually alleviated by grading and graveling roads. In this photograph, the Sequim thoroughfare is being graded with equipment similar to that displayed in front of the Sequim Museum and Arts on North Sequim Avenue.

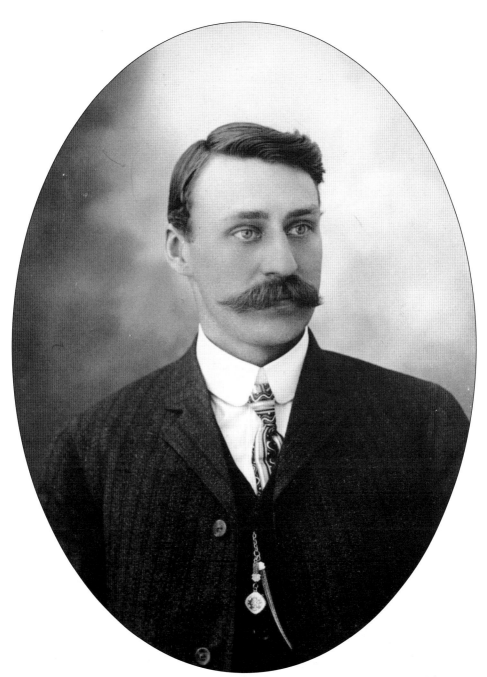

The *Sequim Press* of October 1913 posted a "Notice of Election for Incorporation of the Town of Sequim" on October 14, 1913, to be incorporated as a fourth class town. The Board of County Commissioners determined there were 352 inhabitants living within the territory. The notice read, "The officers and persons duly nominated upon a Citizens Ticket to fill same, are as follows: Mayor Jilson White, Treasurer Hubert Godfrey, Councilman Jens S. Bugge, Frank D. Babcock, Austin Smith, H.P Barber, and Clinton McCourt." The polling place was the Grand Army of the Republic Hall, and Sequim became the second incorporated town in the county. There were 90 votes in favor and 66 against incorporation. Pictured is the first mayor, Jilson White.

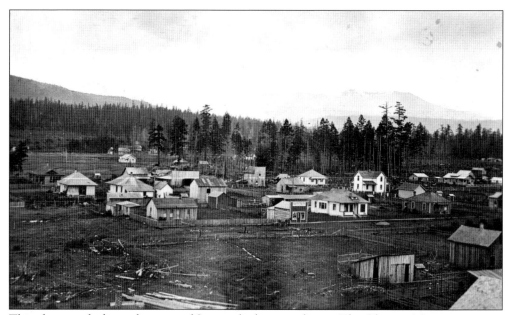

This photograph shows the town of Sequim looking southwest. The Olympic Mountains are in the background. The elevation and direction of the photograph suggest it may have been taken from the roof of the Sinclair Hotel. Some of the wood frame houses are still standing in the neighborhood west of Sequim Avenue.

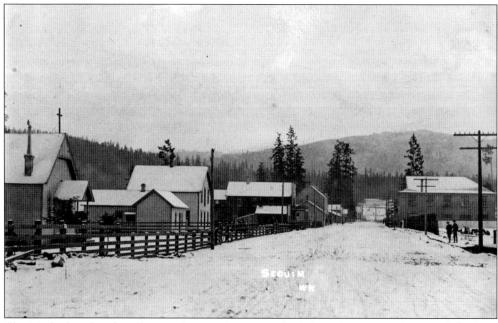

The Methodist church with its gothic windows is on the left in this winter photograph looking south on Sequim Avenue at the intersection with Fir Street. The church building was moved to Sequim from New Dungeness–Old Town. A new church, now the Olympic Theatre Arts building, was later constructed on this site on North Sequim Avenue. The opera house is on the right.

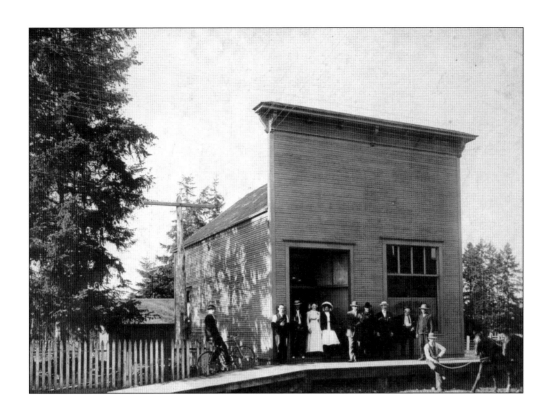

The State Bank of Sequim incorporated in 1910 with $10,000 capital. Fireproof vaults and a steel manganese coin safe were added in 1911. Officers were Hans Bugge, president; J. Adams, vice president; R. Schumacher, cashier; and E. Prim and L. Bigelow, directors. By 1911, the assets were in excess of $50,000, according to George O'Brien in the *Sequim Press*. In 1922, robbers employed an electric drill to open the safe and safety deposit boxes, resulting in a successful manhunt across two counties. Citizens holding boxes were quick to announce their losses in the local press. The money was recovered with the assistance of the surviving safecracker along with a diamond ring and a photo from a gold locket. However, Etta Keeler's bag of gold nuggets remained unfound.

Shown here are the Sequim Creamery (left) and the Sequim Depot (right). The 1913 *Dairy Produce* stated, "Drillers . . . boring for a pure water supply . . . put down a six-inch pipe. At a depth of 280 feet, they struck oil. The discovery was announced at noon and by night every community in the northern part of the Olympic peninsula was excitedly discussing the prospects." The venture was not commercially feasible; butterfat remained the reigning hydrocarbon.

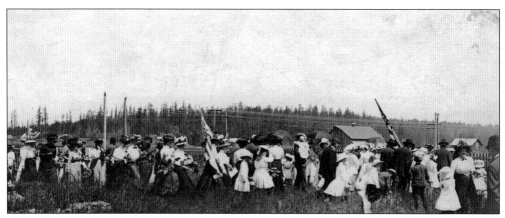

Adult deaths due to tuberculosis, appendicitis, and fatal accidents from logging and hunting were enumerated in the *Sequim Press* during the early 1900s. In the pre-vaccination era, deaths from measles, mumps, diphtheria, and typhoid were very common, and small pox had already decimated northwest tribal villages. Childbirth was risky for both mothers and babies. This cemetery is now Pioneer Park; most graves were moved due to a high water table.

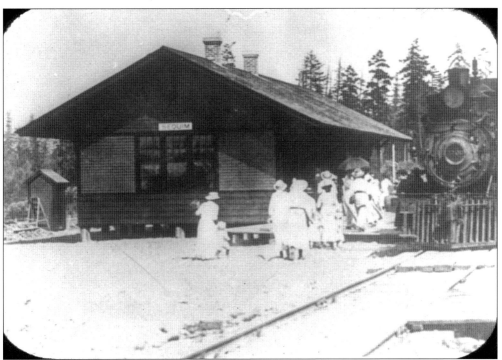

The Sequim Depot is shown above. There had been several attempts at capitalizing a railroad. Thomas Aldwell, who built the Elwha Dam, wished to start an Olympic Peninsula Electric Railroad, but since his idea lacked steam, he lost to G.M. Lauridson and J.F. Christensen. At a 1912 meeting at the opera house, citizens were asked to donate promissory notes, payable when the railroad was completed. The Sequim Commercial Club signed an agreement with C.J. Erickson to obtain the right-of-way if he would construct 70 miles of railway. After numerous delays, the Chicago, Milwaukee, St. Paul & Pacific Railroad ran through Sequim. The train crosses Railroad Bridge, built in 1916, in the photograph below.

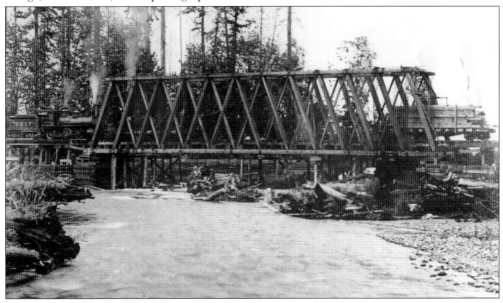

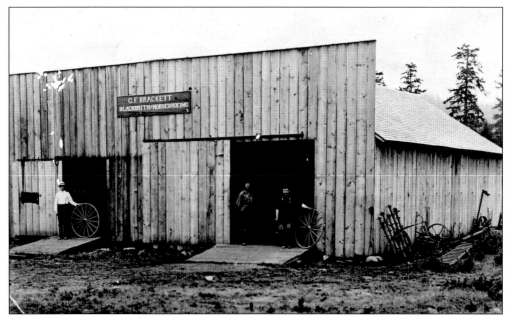

Brackett Blacksmith & Horseshoeing was located on Bell Street near The Corners saloon. Blacksmiths were essential to pioneer life, as they constructed and repaired wagons, wheels, farm equipment, and household items. George Bracket moved with his wife to Sequim in 1903 from Minnesota, where he had been a leading amateur baseball player. His obituary noted he "could always be depended upon to carry on for his home community."

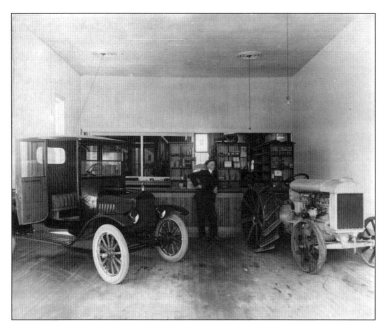

Calvin Lightheart opened a Ford dealership on east Washington Street in Sequim with Verne Samuelson after serving in the Hundred Days Offensive along the Western Front with the 91st Division during World War I. A friend noted on the reverse of this photograph that Lightheart was doing so well he was about to pay back startup funds borrowed from the G.I. Insurance.

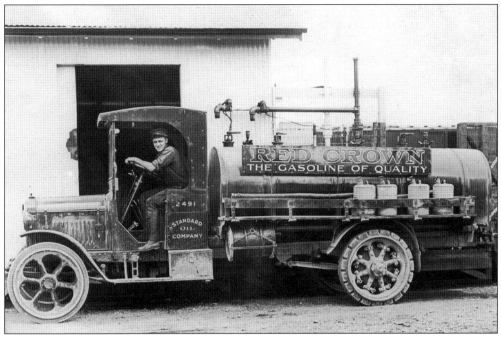

This photograph shows Bill Alton, who worked for the Standard Oil Company, delivering Red Crown gasoline. Many farms had their own gas tanks at that time for tractors and other heavy equipment. In 1911, Standard Oil was ordered by the US Supreme Court to split into 34 companies, under the Sherman Antitrust Act. According to Chevron history, Red Crown was one of the products of Standard Oil of California that had increased its oceangoing tankers between 1912 and 1916; by 1926, it had a fleet of 40 vessels, including stern-wheelers, barges, tugboats, and oceangoing tankers. The photograph below shows the Sequim Garage and Towing Service and the Phillips 66 station, which sold Atlantic Richfield gasoline.

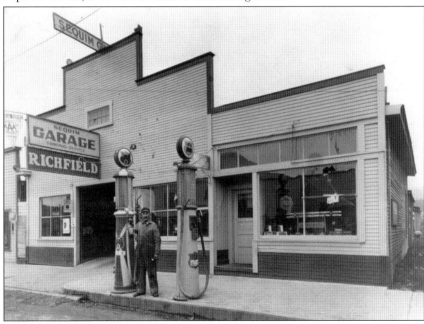

St Joseph's Mission in Sequim was established as part of the Queen of Angeles Parish in Port Angeles in 1916. Joseph Keeler donated the land for a chapel that was blessed on January 9, 1916. The first pastor was Fr. Albert Erkins. A new church was built on the original site in 1966.

Sequim mayor William Schumacher had a grocery store on north Sequim Avenue. Other businesses included Austin Smith's Cash Store (nuts, candies, fruits, art goods, pictures, hardware, groceries, paints, wallpaper, building materials, picture framing); a millinery shop; and a pool hall, bowling alley, dance hall, and skating rink (all built by George Sherbourne) in a two-story building on Sequim Avenue near the bank.

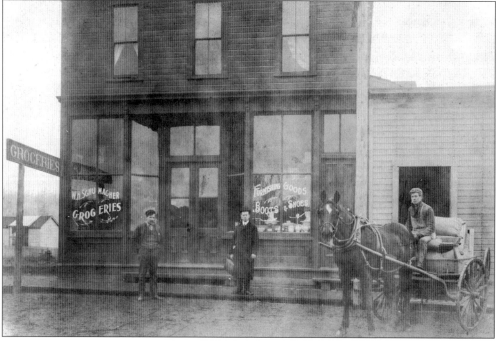

The grain elevator was built along the railroad tracks in the 1920s. There were several compartments inside to store different types of grain. The Clallam Grain Company owned the building, and it later became a shopping and restaurant center. The only available photographs were all taken post-1930, so shown is an Irrigation Festival Parade, featuring the Sequim High School Band under the direction of Vern Foskett. (Photograph by Katherine Vollenweider.)

Effie Pilcher was the proprietress of the Pioneer Bakery and Restaurant on West Washington Street in the early 1900s. She offered board and lodging, good rooms, meals served to order, and reasonable rates, according to her 1911 *Sequim Press* advertisement. Glendale ice cream and fresh bread were offered daily. Pilcher is shown standing on the porch.

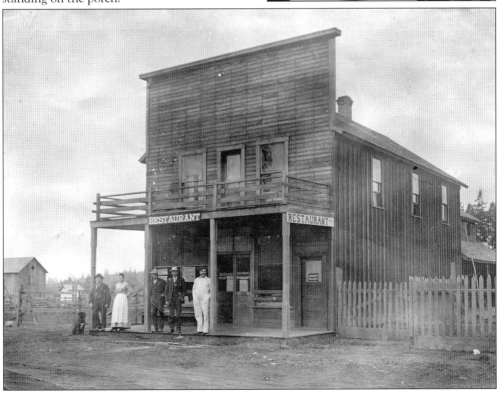

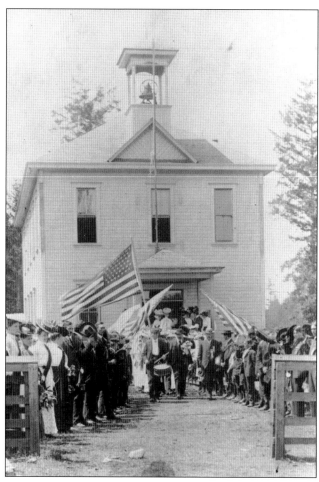

Classes started in April 1891 in this schoolhouse (also shown at left in the photograph below). The March 1891 *Port Angeles Herald* reported from Long Prairie [Sequim], "The snow is leaving us after a protracted stay of five weeks. The ground for the new schoolhouse is being cleared by Lewis Roberson and work . . . will commence next week. Mr. Hall of Lost Mountain has the contract for the building. It will be the second best schoolhouse in Clallam County and will cost about $900. . . . As Dungeness has collapsed entirely since the removal of the county seat, Long Prairie expects to come to the front at once. A farmer's store is soon to be erected, a sawmill will soon be running, and a church is talked of in the near future." After 1911, an auditorium was added upstairs, and manual training classes were held.

This schoolhouse (above left) was built in 1911 by renowned architect James Stephen, who developed a model school plan while lead architect at Seattle Public Schools. The district investigated enlarging the 1891 two-story school (below center). However, as the *Sequim Press* reported, new codes had been established for ventilation and lighting that the building did not meet; it was afterwards used for manual training and other activities. The district's appraisal was $199,753, and voters approved a $6,000 bond for the new schoolhouse. The $125 bid by Lindoerfer and Leper for foundation excavation included removal of the one-room schoolhouse to the right. J. Long's Riverside Logging Company milled the timber. The dedication was on February 24, 1912. The McKissick photograph below also shows Sequim High School at far left.

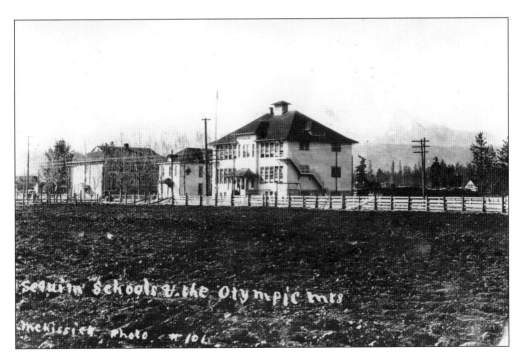

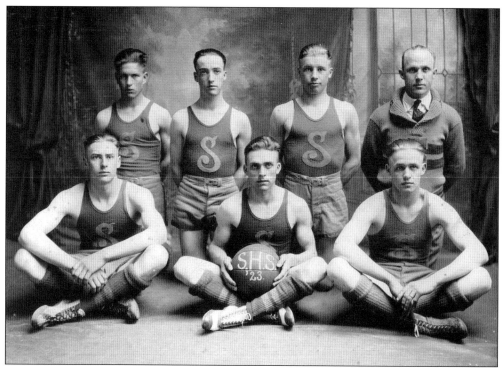

Shown above is the 1923 Sequim High School boys' basketball team, organized in 1912. The team won Peninsula championships in the 1917–1918 and 1920–1921 seasons. From left to right are (first row) Theodore Munsen, Iris Marshall, and William Alton; (second row) Adrian Prim, Orie McKinney, Maurice Van Antwerp, and Paul Davis (coach). The Sequim High football team (below) was organized in 1914. From left to right are Buck Prince, Bill Wheeler, J. Evert Soderberg, James Hogan, Angus McNamara, Fred Chase, Ernie Hamilton, Fat Hagerty, Levi Cays, and Merle Fisher.

In this photograph, the 1918–1919 Sequim High School girls' basketball team waits for a ferry from Port Williams to Port Townsend for a game. From left to right are Lou Woodcock, Janice Hooker, Barbara Govan, Ellen Kirner, Grace Myers, Ruth Alton (captain), and Hannah Larson (coach). Sequim also had young women's basketball teams for those who had already graduated.

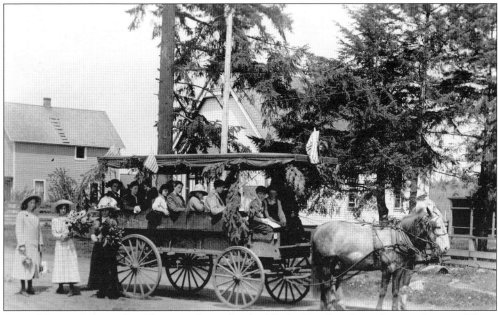

One of Sequim's first school buses is shown by the Methodist church on Sequim Avenue. There were 146 students in 1911. The district accepted bids for the "hauling of all pupils . . . to Sequim school during . . . 1911–12, 175 school days. . . . wagon to leave Long's Saw Mill and Sequim school at a time set by principal. Bidder must furnish a good wagon and be a competent adult driver of good moral character."

The Wolf's Snarl was published by Sequim High School students in 1929. Joe Rantz attended Sequim High in 1929 before moving to Seattle. At the 1936 Summer Olympics in Berlin, he won a gold medal as part of the University of Washington eight-oar rowing team.

The first high school graduating class turned their tassels in 1915. From left to right are Leonard Fernie, Helen Knoph, Neva Peterson, and Goodwin O'Brian. The principal was Jess Mantile, and the teachers were Paul Davis and Miss Wallace. The brick high school at the corner of Fir Street and Sequim Avenue gained several additions since it was first built.

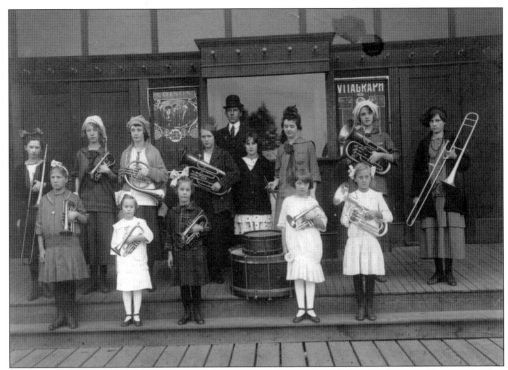

Shown are two recitals at the Olympic Theater. Above, from left to right, are (first row) Elsie Davenport, Gladys Howell, Goldy Lyons, Lela McDonald, and Edna Grant; (second row) DeEtta Waldron, May Kofod, Ellen Kirner, Cora Cays, Zola Grigware, Fern Willis, Ruth Alton, and Agnes Nelson. Below, from left to right are (first row) Freddy Sands, Con Kirner, ? Lyons, Carl Nelson, Malcolm Fromer, Lawrence Black, Eugene Belt, Albert Smith, and John Kirner; (second row) Hans Nelson, Lulu Sherbourne, Ed Sherbourne, Bill Alton, Charles Hamilton, Lloyd Fisher, Bill Grant, Bob Grant, Mr. Davenport, Harry Kirner, Charles Bushnell, and Goddy Smith. Several young musicians later joined the Sequim Town Band.

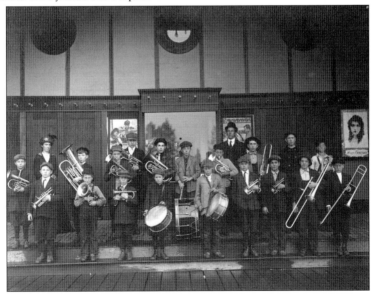

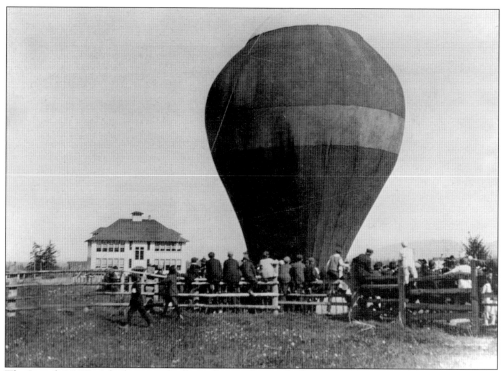

The Joseph McKissick photograph above shows a hot-air balloon at a May Day celebration. Balloon and biplane rides, wrestling matches, horse and foot races, picnics, band concerts, and parades were all part of May Day, as was the celebration of the opening of the first irrigation headgate, a tradition that continues today. Many of the events occurred at Sequim Athletic Park, owned and maintained by the Sequim Athletic Association. Used for community baseball games between Jamestown, Dungeness, and other cities on the sound, the Sequim Athletic Park was sold to the city in 1917. The site is now the Sequim School District athletic fields.

In 1912, the local baseball teams were the Sequim Olympics, Dungeness Ring Tail Snorters, and Jamestown Leaders. Among those pictured at right in Port Ludlow in 1920 wearing "SAC" for Sequim Athletic Club are George Main, Clyde Towne, Frank Cassalery, and Marion Vaughn. Teams traveled by steamship to play Port Townsend, Port Angeles, and other teams along the Puget Sound.

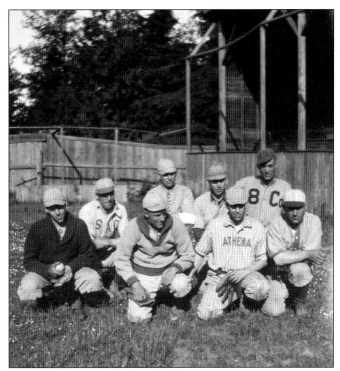

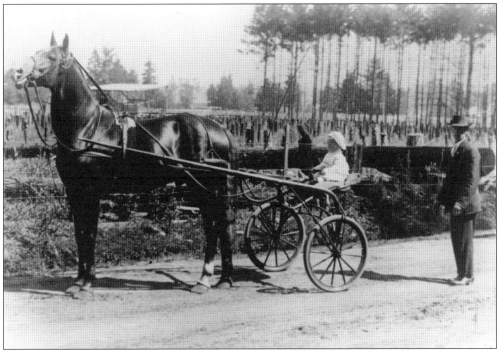

Horse racing was a popular pastime, and races were held on Sequim Avenue until a track was built at the Athletic Field, where this 1912 photograph of a harness racer and sulky was taken. Driving is Stacy Stone, with his father standing by. In 1925, Stone became one of the first scouts in Boy Scout Troop 490. His father, Roy Stone, was on the scout committee.

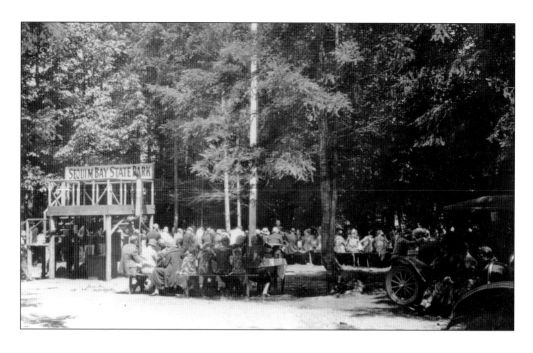

On May 3, 1924, the commissioner of public lands set aside 84 acres for a state park, with about 4,900 feet of tideland on Sequim Bay. Additional parcels were added later. These photographs show the park in its early days. By the 1930s, auto tourism was on the rise. Sequim was connected by rail, but passenger service was discontinued in the early 1930s. Dairy farming and logging were still the economic mainstays until the town experienced an influx of retirees decades later. The landscape of the town and environs changed, reflecting its evolution into the mid-20th century, but the ethos of those who first called it home remains.

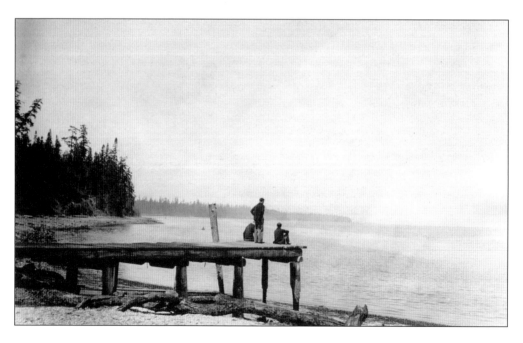

*Six*

# Sequim's Local Ports
## Washington Harbor
## and Port Williams

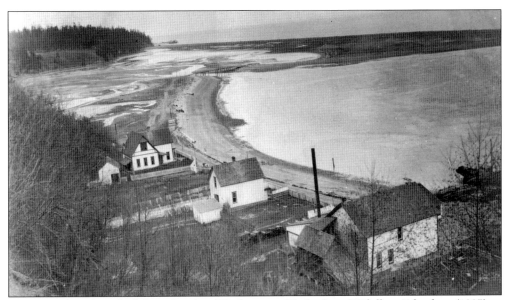

Erna Gunther described Suxtckiwi'iñ (Washington Harbor) in *S'Klallam Ethnology* (1927) as having 10 longhouses and a large potlatch house. The areas provided fresh water, protection from the weather, and copious amounts of shellfish and game birds. Shown are several of the cannery buildings and residences that later occupied the site. Port Williams is barely visible, near the wooded promontory point.

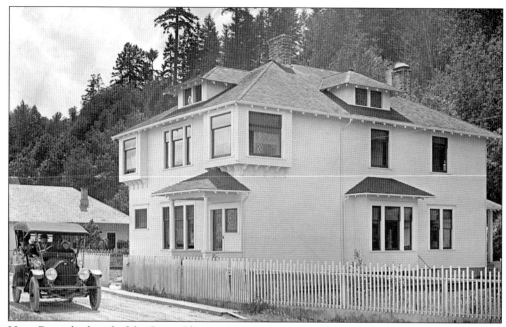

Hans Bugge had worked for Cyrus Clapp in New Dungeness–Old Town before purchasing a wharf and cannery in the 1890s. By 1905, he processed salmon, fruit, vegetables, and clams and built a creamery. His was neither the first nor the last clam enterprise near the mouth of Sequim Bay, but the Norwegian immigrant managed to vigorously dissuade others from competing with his operations. Shown is the house he built near the cannery.

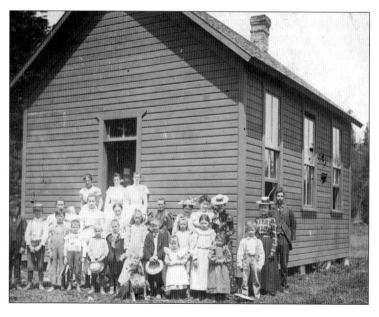

The Washington Harbor Schoolhouse was so close to the water that, at high tides, water reached the foundation. It was moved several times, most recently in 2007 to the Sequim Museum and Arts property on Sequim Avenue. The schoolhouse was once used to store grain for one of the many hunting clubs that existed in the area. Hans Bugge married one of the schoolteachers.

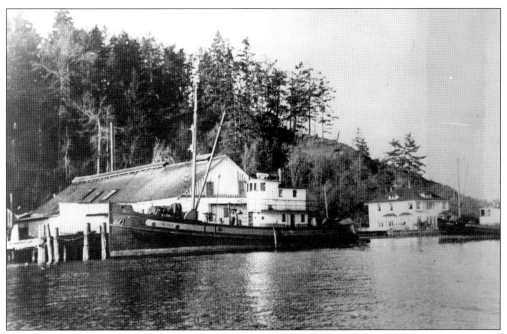

The schooner *Lincoln* (at the dock) was used for tendering clams. The 1919 *Milk Dealer* reported that Hans Bugge had arranged with Seattle capitalists for $100,000 to build a milk condensary capable of outputting 500 cases a day with a greater return for dairymen. A fruit and vegetable cannery was also included in the expansion. Shown below is the interior of the clam cannery. The operation relied on over 400 miles of leased tideland and the efforts of numerous S'Klallam clam harvesters. Bugge developed markets for both fresh and canned clams and clam nectar; he canned fruit and salmon during the off-season. The area later became Battelle Pacific Northwest National Laboratory's Marine Sciences Laboratory.

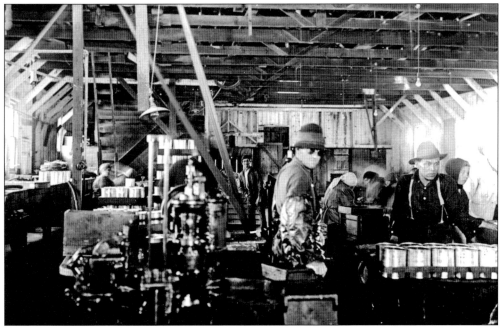

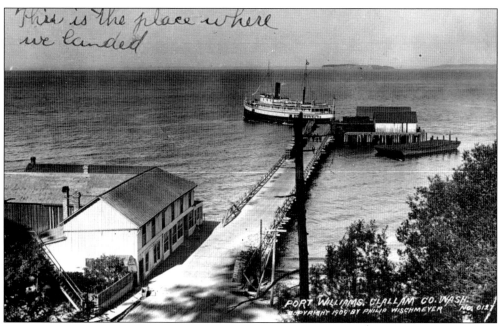

*This is the place where we landed*

PORT WILLIAMS, CLALLAM CO. WASH.
COPYRIGHT 1909 BY PHILIP WISCHMEYER   NO. 0127

At one time, Port Williams was the main supply route for Sequim from Seattle, Victoria, and Portland. Homesteaded in 1882 by Frank James, Robert Travers, and James Woodman, there was a post office and Western Union Telegraph Company station. It remained a voting precinct through the 1960s. Ships arrived daily from Seattle en route to Clallam Bay or Neah Bay. Shown above is the hotel and store, a warehouse at the end of the wharf, and the steamship *Alice Gertrude*. Travers, who sold the Port Williams site to Hans Bugge, was granted a ferry route by the territorial legislature to run a small ferry servicing the Discovery Bay Mill; the fare was set at 75¢. The photograph below shows the port from the water.

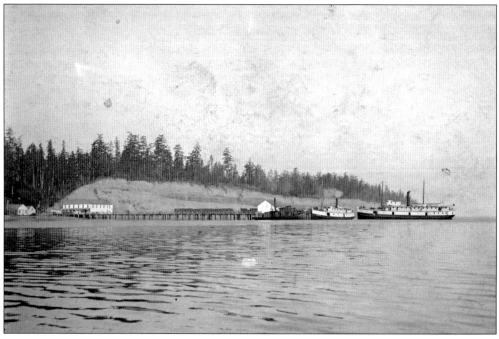

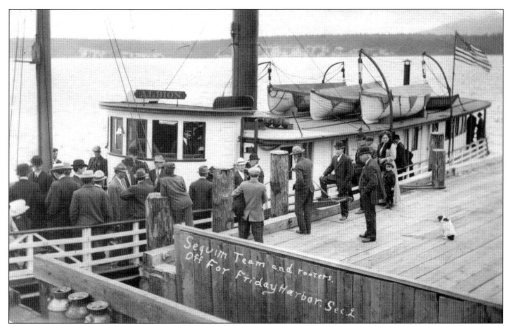

This McKissick photograph shows the Sequim baseball team and fans boarding the Straits Steamship Company's *Albion* for a game upsound. *Albion* stopped at Port Williams, then continued to Port Angeles, Port Crescent, Gettysburg, Pysht, Callam Bay, and Neah Bay. Joseph Keeler often accompanied the team to games and the legend goes that running low on fuel on a return trip one evening, he persuaded the team to utilize their personal stash of libations.

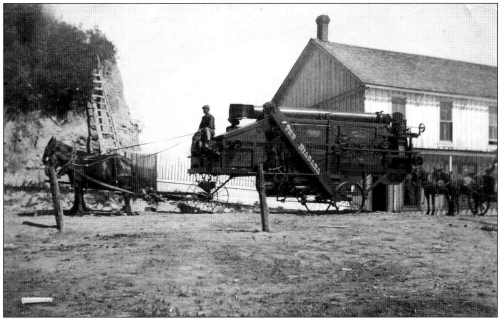

In this photograph, Matt Fleming's horse team pulls a thresher from the Port Williams wharf. In 1910, the Buffalo Pitts Company introduced the Niagara thresher. Their manufacturing plant was along the Erie Canal and received its electricity from Niagara Falls. The Pitt brothers invented the continuous apron threshing machine, and this one came by steamship to Port Williams.

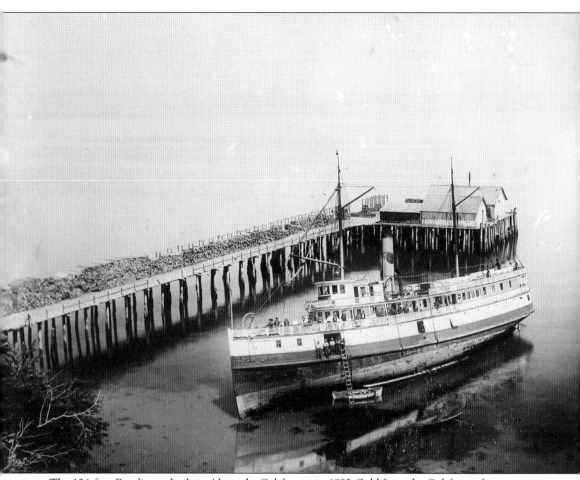

The 136-foot *Rosalie* was built in Alameda, California, in 1893. Sold from the California ferry service, she joined the supply route to the Klondike Gold Rush with other ships from the Mosquito Fleet. In 1900, Joshua Green of the La Conner Trading and Transportation Company purchased *Rosalie* and ran mail to Port Williams and Dungeness. Green later merged with the Alaska Steamship Company and formed Puget Sound Navigation Company. Careening a ship for maintenance was a common practice. Work appears to be in progress near the stern. The bilge keel kept *Rosalie* from rolling while on the beach. In 1918, *Rosalie* burned while at the dock in Seattle. Cordwood for steamship fuel is stacked on the Port Williams wharf.

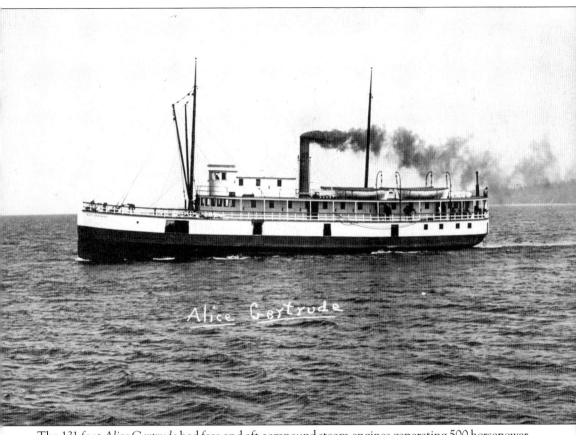

Alice Gertrude

The 131-foot *Alice Gertrude* had fore and aft compound steam engines generating 500 horsepower. Built in 1898 for the Thompson Steamboat Company, she stopped at Port Williams and Dungeness en route to Neah Bay. Owners Fred and John Rex Thompson named her for their two daughters. In 1907, under 16-year veteran Captain Charles Kalstrom, she developed leaks in her steam connections close to Neah Bay; lacking safe anchorage, Kalstrom returned to Clallam Bay. The Slip Point foghorn was nonoperational. In the ensuing snowstorm, he mistook a land light for the wharf, and the ship grounded with no casualties. The vessel was declared a $40,000 loss and her engine and boiler salvaged and installed in the steamship *Independent*.

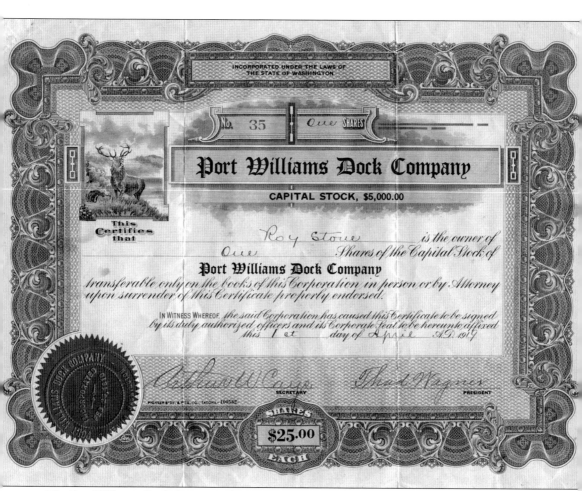

The Port Williams Dock Company shares were offered for $25 apiece in 1919, with a capital stock of $5,000. This certificate was signed by Arthur Cays and Thad Wagner and issued to Roy Stone. By 1922, the wharf was in disrepair, and ship traffic arrived at Washington Harbor for cargoes of clams and creamery products. The site is now Marlyn Nelson County Park, named in honor of Nelson, who perished on the USS *California* during World War II.

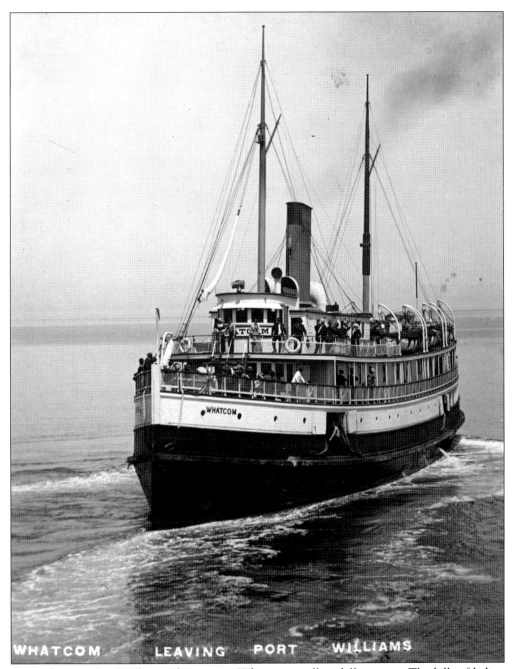

WHATCOM    LEAVING    PORT    WILLIAMS

Shown leaving Port Williams, the steamer *Whatcom* recalls a different era. The bills of lading from the local sail and steamship trade were diverse, including all the pleasures and necessities of life. Everything from farm equipment to church bells came by ship to local ports. Ships that used the wharf at Port Williams included the *Alice Gertrude, George E. Starr, Excelsior, Albion, Pinto, Dispatch, Tyee, Monticello, Bellingham* (formerly the *Willapa*), *Rosalie, Whatcom, City of Angeles, Evangel, Sioux, Sol Duc, Utopia, Iroquois,* and *Wealleale,* as well as the tugs *Rhododendron, Katy, Pearl, Wasp, Bee,* and others, upon whose decks stood those who toiled and dreamed of a prosperous future.

# DISCOVER THOUSANDS OF LOCAL HISTORY BOOKS FEATURING MILLIONS OF VINTAGE IMAGES

Arcadia Publishing, the leading local history publisher in the United States, is committed to making history accessible and meaningful through publishing books that celebrate and preserve the heritage of America's people and places.

Find more books like this at
## www.arcadiapublishing.com

Search for your hometown history, your old
stomping grounds, and even your favorite sports team.